DIRECTOR'S CHOICE
CHATSWORTH

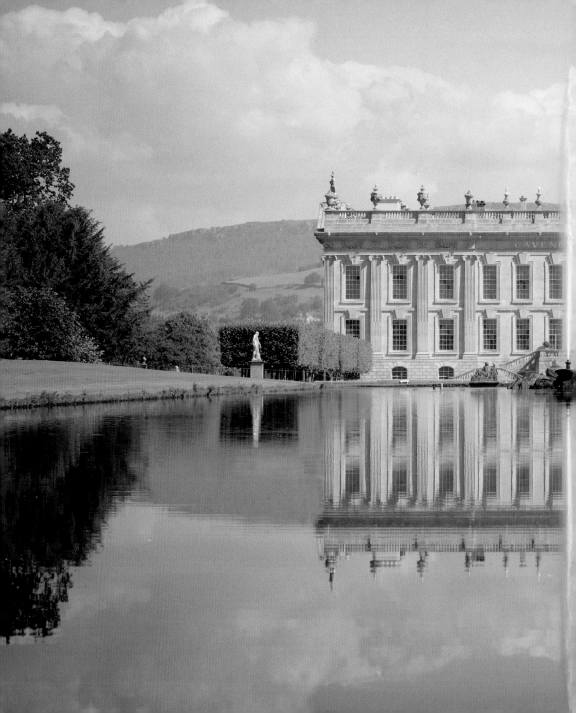

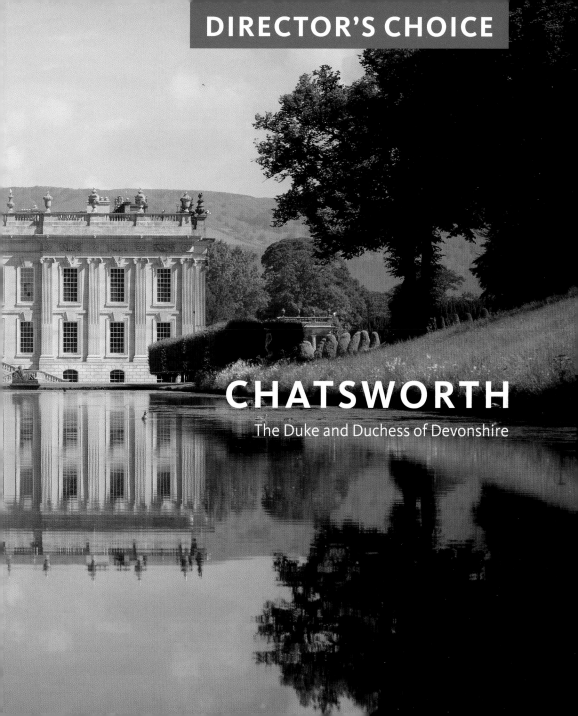

CHATSWORTH

The Duke and Duchess of Devonshire

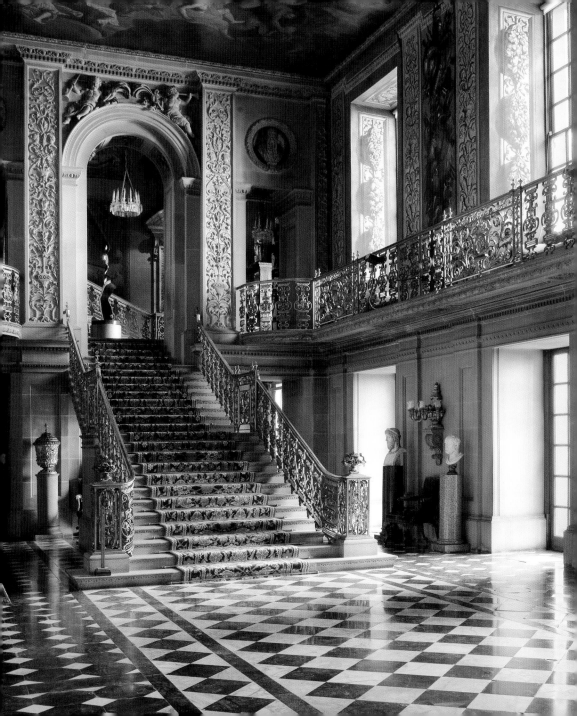

INTRODUCTION

WE ARE VERY LUCKY to live at Chatsworth, surrounded by objects collected over 16 generations, with views of sublime beauty and peace from every window. As my wife, Amanda, and I learn more about the history of the house, garden and park, and come to appreciate the objects and paintings in the collection, we realise the complexity of Chatsworth.

Neither of us knew much detail of the history of the house and its contents until we came to live here in 2006, but since then, with the help of several knowledgeable and patient tutors, we have begun to understand the general history of the place, its owners and its contents, both inside and out.

In this short book of some of our favourites we have included many that are comparatively new to us, such as the Roman marble statue of a lady and her daughter and the curious box of tools belonging to Antonio Canova, some things which we have known and loved for years, such as the Regency Bed in the Leicester bedroom and the decorative marble floor at the entrance to the Painted Hall, a few things we brought with us or have commissioned and some views of the outside, both domestic and grand.

It is only in the last few months that it has become certain that there was a house, probably a manor house, on the site of what is now Chatsworth. Oliver Jessop has pieced together irrefutable evidence, based on his discoveries during the excavations that have been a necessary part of the current and continuing major restoration. This includes parts of a pre-Elizabethan arch in the cellars underneath the northwest corner of the house.

Little is known for certain about Bess of Hardwick's building here, but there are two reasonable images of its west front: one a later copy of a now lost contemporary painting, the other a needlework rendering of the same west front. Mark Girouard wrote a compelling article in *Country Life* (27 November 1973) describing how he believes the rooms were arranged inside this mysterious Tudor stately house.

We know much more, however, about the history from the time that the 1st Duke started to rebuild what must have been an uncomfortably old-fashioned and impractical principal residence in 1687, and indeed we

The Painted Hall, 1689–91, with later staircase and gallery from 1912

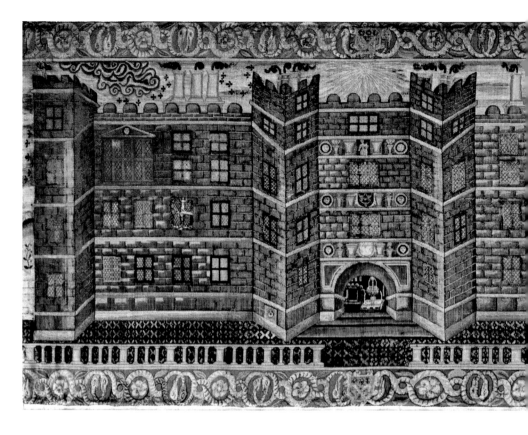

have continued to learn throughout these last three years as our builders have opened up so much of what has been hidden for a long, long time.

The collections have been documented since their formation. The Cavendishes and the architect Lord Burlington were immensely proud of what they accumulated and loved showing their acquisitions to their friends, some of whom inevitably wrote down what they had seen and heard.

Perhaps the most significant addition to the Chatsworth collection of Old Master Drawings was the purchase *en-bloc* by the 2nd Duke (1673–1729) in 1723–24 of the collection made by Govaert Flink (1615–1660). That Duke also acquired remarkable paintings as well as

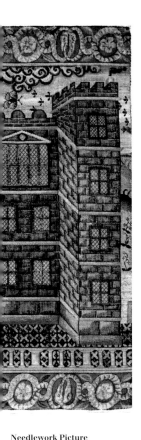

Needlework Picture of Chatsworth

Silk threads on linen, c.1590–1600

a large collection of antique and Renaissance gems for which he commissioned special cabinets in *boulle* marquetry. The 3rd Duke (1698–1755) added further to the collection of Old Master Drawings. He also purchased one of the most important paintings in the collection today, *A Man in Oriental Costume* (or *King Uzziah Stricken by Leprosy*) by Rembrandt van Rijn (1606–1669), which he bought in 1742 at a cost of over £78 (see back cover).

In 1748 the future 4th Duke of Devonshire (1720–1764) married Lady Charlotte Boyle (1731–1754), the 3rd Earl of Burlington's only surviving child. Their son, the 5th Duke (1748–1811), eventually inherited the entire Burlington collection of superlative fine and decorative arts, architectural drawings and a library, as well as Chiswick Villa and other estates. This inheritance doubled the extent and more than doubled the quality of the Devonshire collection.

The 6th Duke (1790–1858) was both a serious collector and magpie accumulator. His remarkable collection of then contemporary sculpture, his mania for marble and minerals and his competitive book collecting, which rivalled that of his uncle, the Earl Spencer, are just a few of the highlights of his eclectic and extravagant lifetime's passion.

The history of the Garden and the Park is much more difficult to disentangle. Excellent work by Tom Williamson, John Barnatt and Nicola Bannister and others in 1998, and now the beginnings of the thrilling cooperation between the Peak District National Park, Natural England and our family Trustees (which will result in a 20-year management plan for the Park), have helped and will continue to help unravel the complex history of these 1,000 acres of now grass, trees and forestry, with the village and church of Edensor balancing the house as central foci for the landscape.

All four components – collection, house, garden and park – are wrapped together in a single work of art that has taken 460 years to construct and which is by no means finished. We have arranged our choices for this book in the order that our visitors normally would see them. We hope our visitors will enjoy this personal mini-tour. No doubt those who visit often will have their own favourites, and I hope they tell us what they wish we had included.

The major work that we are orchestrating – the cleaning, repairing, refurbishing, redecorating and generally making good – is possible thanks

to the extraordinary dedication of my parents and those who helped them. When my father inherited Chatsworth and its estate in 1950, the situation was extremely grave: their tax bill of 80 per cent of the value of every acre, building and chattel seemed almost too huge a problem to overcome, and alternative uses for Chatsworth were widely accepted as inevitable. But my parents were young and determined, and they managed, slowly and with great difficulty, to keep Chatsworth as a private home as well as an increasingly popular tourist destination. By the time my father died, in 2004, the situation here had been utterly transformed. His creation of the Chatsworth House Trust in 1981 was the final piece in the strategic plan which appears to have secured Chatsworth as somewhere for visitors to enjoy for the long term; the fact that it remains our family home is a huge bonus for us, but this is no longer the main purpose of what has been created over centuries. The Chatsworth House Trust also allows us to continue to enhance the historical collection by acquiring artworks and objects that once belonged to the collection or relate closely to the history of the house or the Devonshire family. One such is the infamous 'stolen' portrait of Georgiana, Duchess of Devonshire (1757–1806),

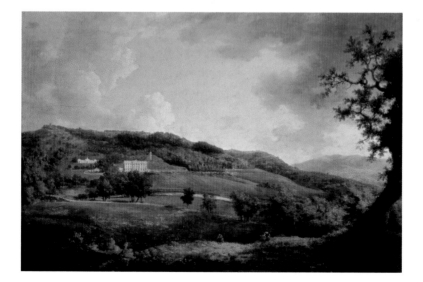

A view of Chatsworth
WILLIAM MARLOW
(1740–1813)
Oil on canvas, c.1770

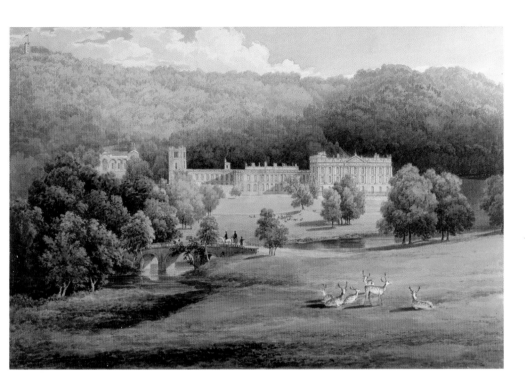

View of Chatsworth from the West

WILLIAM COWEN (1791–1864)
Watercolour, 1828

painted by Thomas Gainsborough (1727–1787) and bought by the Chatsworth House Trust in 1994 (see front cover).

Without visitors Chatsworth would be an empty, echoing shell, a lifeless mausoleum. It is not only the financial support that makes these visitors so welcome; it is because they bring Chatsworth alive. They populate the State Rooms and give those potentially rather dreary spaces the most useful and rewarding function since they were completed. Visitors give the garden and the park the right scale, and they give all of us who live and work in or near Chatsworth the best possible reason to continue to strive for improvement and innovation. They now are Chatsworth's *raison d'être*, and if this book enhances just a few visits, then some of the enormous debt that we owe our visitors will have been partially repaid.

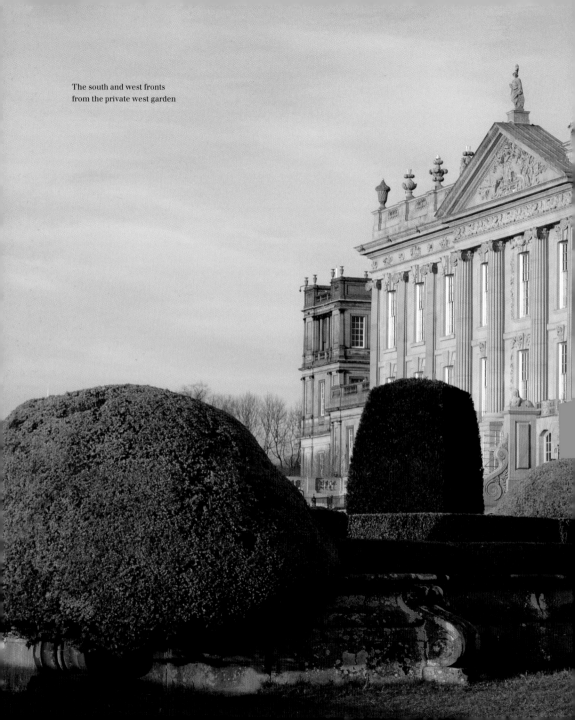

The south and west fronts
from the private west garden

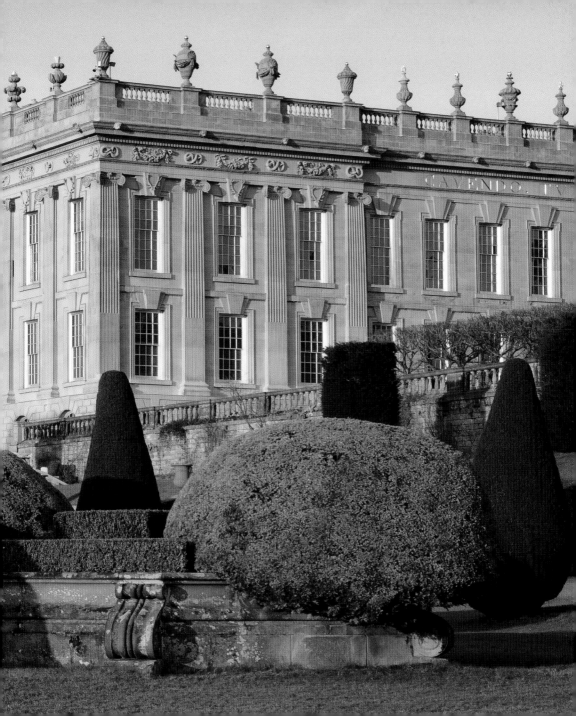

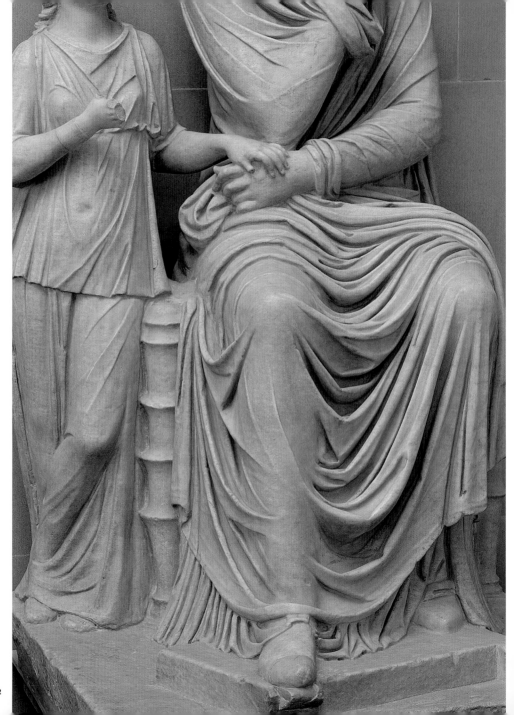

Statuary Group of a Lady and her Daughter

ROMAN
Marble, c.AD 100

PLACED IN THE FAR CORNER of the North Front Hall, this wonderful life-size group of a Roman lady and her daughter, now nearly 2,000 years old, has been at Chatsworth since 1822. It was purchased by the 6th Duke of Devonshire (1790–1858) during the sale of the contents of Wanstead House, created by Richard Child in the early 1700s and sold off and demolished by 1825; this sale coincided with the period of my forebear's most energetic collecting.

The carving of the clothes is staggeringly accomplished. The fabric of the mother's garment sags slightly between her knees and hangs down over her legs in a completely realistic way. The facial expressions portray two very real people, pensive and composed, patiently waiting or listening, their attention on different objects. Their distinctive hairstyles, which have been beautifully portrayed by the sculptor, clearly indicate the social importance of the sitters.

That this statue sits in the background, when it should dominate a whole room, is somehow typical of Chatsworth, which is stuffed to overflowing with extraordinary and beautiful things. There simply isn't room even in this huge house to display more than a few as they should be. However, for those inquisitive visitors a few minutes spent contemplating it will be well rewarded.

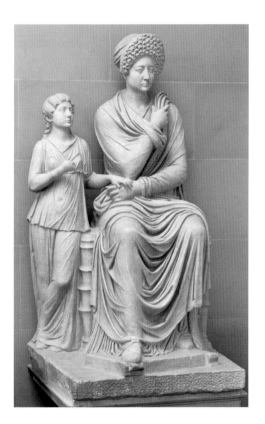

Decorative Marble Floor

Various marbles, 1779, relaid in the 1820s

THIS PIECE OF FLOOR, along with the other large decorative panel now under the ping-pong table below the Great Stairs, is all that remains of the floor laid for the 5th Duke (1748–1811) in 1779. His floor replaced the plain gritstone floor that was part of the 1st Duke's Painted Hall when he rebuilt Chatsworth between 1687 and 1707.

As you leave the North Sub Corridor to enter the Painted Hall, you see the four former corners from the central decorative element of the 5th Duke's Painted Hall floor put together in a very pleasing pattern. This was done by Sir Jeffry Wyatville (1766–1840) for the 6th Duke in the 1820s, when connecting the Painted Hall to the newly enclosed North Sub Corridor. This relaid section of floor now acts as a transition between Giuseppe Leonardi's (active 1830s and 1840s) brightly coloured marble pavement of 1841 in the North Sub Corridor and the black and white marble floor in the Painted Hall.

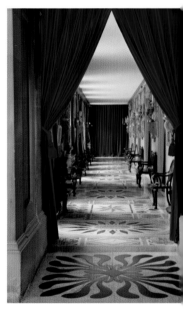

There are three or four different marbles in the design. White veined marble is used for the background and plain white for the central star, which sits on a grey background of what we call 'Once a Week' marble. The quarry that this stone comes from, about 10 miles east of Chatsworth, has produced an enormous amount of crinoidal limestone, used throughout the house by virtually every generation of the Cavendishes – in our case for such modern improvements as shower walls. The sinuous black design is made of another local stone, Ashford marble, which is limestone permeated with bitumen. This too is still quarried locally, although in comparatively small quantities. Much was used by many of my building ancestors, including Bess of Hardwick. Unfortunately this stone fades in sunlight and quickly loses its lustrous black sheen, and so, for instance, the pillars in the Chapel have become a paler grey. Here, however, it is safe from light.

The North Sub Corridor, enclosed from an open colonnade by the 6th Duke of Devonshire

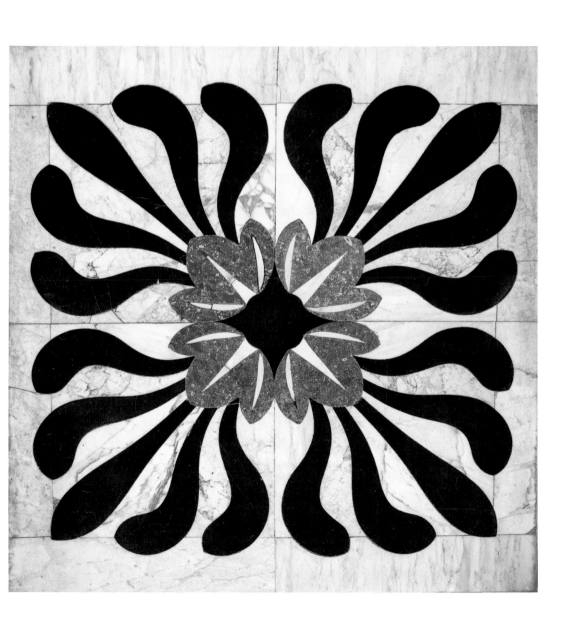

Inner Court

In 2009, when the scaffolding was finally removed from the east side of the Inner Court and the elevation was revealed in all its gilded glory, we knew that our decision to repair and restore the outside of the 1st Duke's house had been worth all the trouble and the inconvenient darkness caused by the scaffolding.

Not surprisingly, after 300 years of weather and perhaps 130 years of industrial pollution, by the beginning of the 21st century the Inner Court was a dank and cheerless space even on a sunny day. My parents made one big improvement in replacing the flowerbed formerly contained within the marble basin with a cheerful fountain. But the more recent wholesale cleaning and repair of the walls and floor of the Inner Court were essential, for structural and aesthetic reasons, as much of the original 17th-century stone carving was falling to bits. Consequently, we chose a complete programme of restoration of the whole Inner Court, including new windows in the south and west galleries of the second floor, which had previously been electrically lit tunnels of gloom; we thought it much more sensible to carry out all these works at once.

The crinoidal limestone basin will one day have a new fountain in the middle, perhaps a commission from a contemporary artist. We will have some new seats on the south-facing wall for people to enjoy the Derbyshire sunshine, and perhaps four large sculptures between the windows on the east elevation. Some colour and height here would be the final part in the restoration of this now rather lovely space.

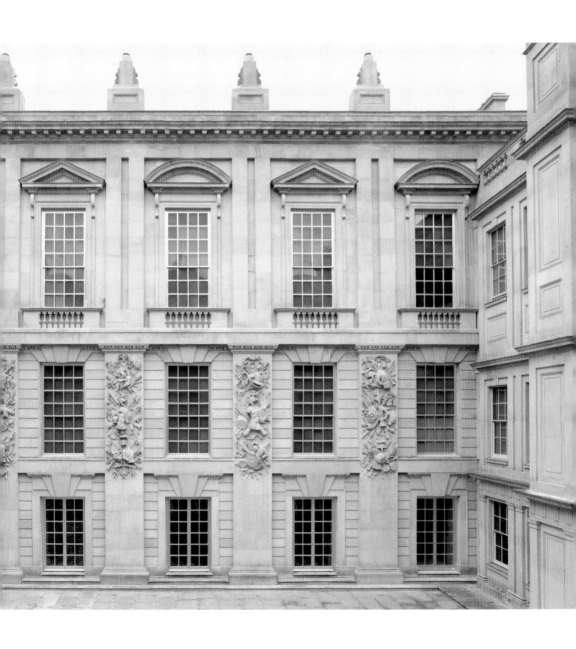

A Sounding Line

EDMUND DE WAAL
Porcelain with cream and celadon glazes, 2006–07

SEEING EDMUND DE WAAL'S (b. 1964) large show at Blackwell in the Lake District in 2005 opened my eyes to the possibility of him doing some sort of site-specific installation here. Edmund came to Chatsworth several times and tried various ideas in different rooms, but eventually we decided that it would be better to start afresh, and agreed that the Chapel Corridor was the best site. The making of the large pots particularly is technically very difficult, and they are a huge physical achievement from that point of view alone.

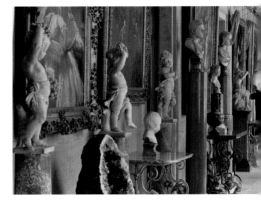

To have these wonderful pieces, which Edmund has described as a 'cargo' of pots, filling one side of this stony passage is simultaneously very intriguing and calming. At first sight they appear to be all white glaze, but looking a little more slowly you see there are subtle differences in the glazes, both of colour and of texture, and the ensemble never looks the same: it is affected by the play of light and shade at different times of day. Amanda and I walk up and down this gallery often every day – it is between our office and our front door – so we see these beautiful objects in a hurry and at leisure, in a crowded space and when empty late at night. We are very lucky to have them.

The Chapel Corridor, with an eclectic display of Old Master paintings, antique sculpture and minerals

At about the same time as Edmund was working on this commission Amanda, Jonathan Bourne, a friend and decorative and fine arts specialist, and I decided to make this space into something akin to an 18th-century sculpture gallery with contemporary additions. Not only has the huge amethyst, a Christmas present from my mother to my father, found a good home, but so have a number of other minerals collected by my father – including a piece of slate with a fossilised fern across its face which I gave to my father for Christmas a few years before he died.

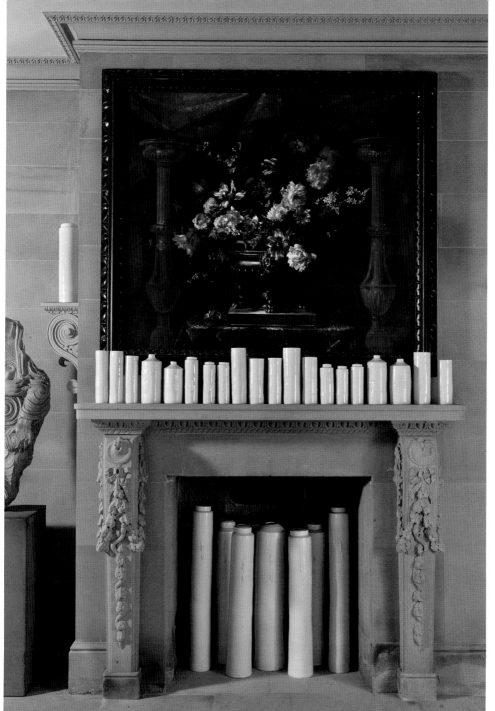

Views of Cullercoats, near Newcastle

JOHN WILSON CARMICHAEL (1799–1868)
Oil on millboard, 1845

ONE OF THE MANY brilliant things that my parents did was to make a door between the Chapel and the Oak Room, which allows visitors to go directly from one to the other. Even with this great improvement, the Oak Room always seems rather crowded, even claustrophobic. The tiles give it the feeling of a Turkish bath, and the heavy carved woodwork, which was bought by the 6th Duke on a whim, is totally untypical of the rest of Chatsworth. But he was charmed by the result. Even with the patina of age I find it hard to like this room, but I do like the little paintings of Cullercoats and other holiday destinations, which the Duke had installed in the panels at a height that both children and adults can enjoy. The Duke loved the northeast coastal village, with the bustle of shipping and the dramatic seascapes, and wrote about it charmingly.

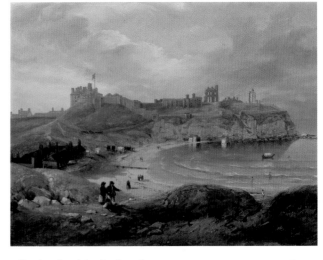

Prior's Haven, Tynemouth
Oil on millboard, 1845

Early in the 20th century Duchess Evelyn banished what she called 'pleasant but quite valueless oil paintings of seaside resorts and other places' to Lismore in Ireland. In 1997 my parents very wisely brought them back and placed them where the Bachelor Duke had originally hung them. When asked for some suitable hinges to hang them with, the house joiner disappeared off to his workshop, quickly returned and, with a satisfied look, produced an old cigarette tin containing hinges, the lid carefully labelled 'hinges removed from Oak Room panel paintings'.

Shields from the Harbour Mouth
Oil on millboard, 1845

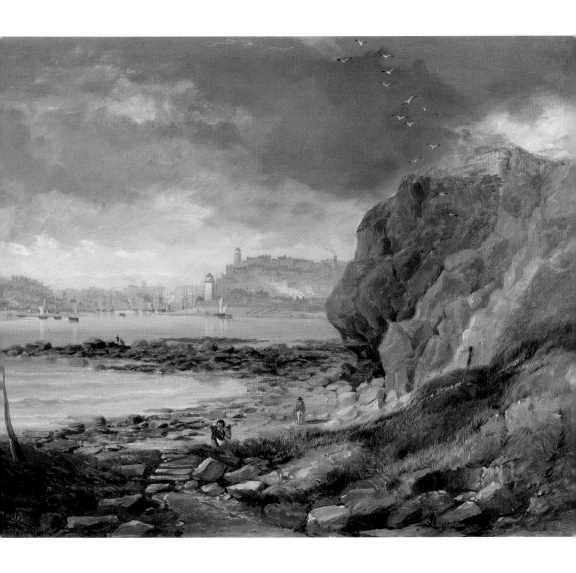

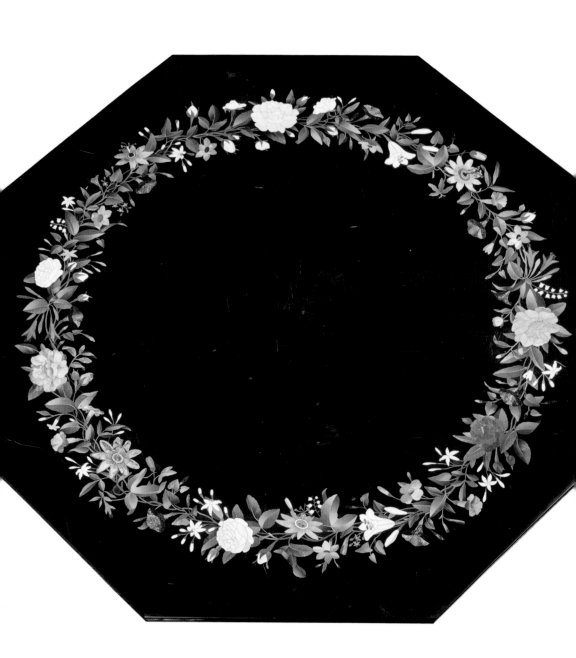

Pietre Dure Centre Table

DERBYSHIRE
Black 'marble', mid-19th century

THIS IS ONE OF SEVERAL TABLES made in the mid-19th century by local craftsmen. This black 'marble' comes from a mine in Ashford, a few miles away, which is still being worked, albeit sporadically and for comparatively small quantities of stone. To call this stone marble is not strictly accurate; it is limestone infused with bitumen, which responds very well to polishing. Bess of Hardwick used a great deal of this stone when she built the New Hall at Hardwick towards the end of the 16th century, and it has always been popular with the builders and rebuilders here (see pp. 14).

There is a tall vase of similar design to this table, currently placed in the window of the Queen of Scots Lobby, which my father bought in London and brought back to its native Derbyshire. There are a number of smaller pieces of inlaid work around the house probably acquired by the 6th Duke. In 1845 he wrote about this table: 'The black table shows you how well we get on in Derbyshire with inlaid work. With pains and better taste we might reach Florence in time.' The 6th Duke was proud of this locally manufactured table, and I agree that it has much to recommend it. The inlay work is to a very high quality, the design is attractive and the table works well in any setting.

Chapel Panelling

SAMUEL WATSON
Carved limewood, 1689–1691

FRANCIS THOMPSON, when researching his *History of Chatsworth* (1947), found in the 1st Duke's building accounts the references to these and all the other decorative carvings in the house being produced by the carver Samuel Watson (active late 17th–early 18th century) and his team of assistants. That for many years the work was accepted as that of his more famous master, Grinling Gibbons (1648–1721), is high praise for Watson.

The 6th Duke commented: 'The Chapel is the least altered place at Chatsworth: painted by Verrio, carved by Gibbons, what could be left for Sir Jeffry to do?' In the upper part of the altarpiece is a painting by Verrio of *The Incredulity of St Thomas* (see p. 26), but the rest of the painting in this room is by Louis Laguerre; indeed, his signature 'L LAGUER' was recently discovered under a ragged fringe of dark cloth behind the legs of the figures on the west wall. I am afraid, therefore, that the 6th Duke was almost entirely wrong with both of these attributions.

Samuel Watson was a local man who lived in Bakewell. He worked at Chatsworth for 20 years, carving in stone and wood in many parts of the house. His carved panels in the Chapel are almost as new – much cleaner and less damaged than similar works upstairs in the Great Chamber – so this is where to look at Samuel Watson's work. The detail is remarkable, entirely naturalistic and mostly botanically accurate. There is evidence of some sort of wood-eating beetle, which was dealt with years ago, and now, with the light properly controlled and the wood looked after according to best practice, there is no reason to think that these panels will not remain as they are for very many years to come.

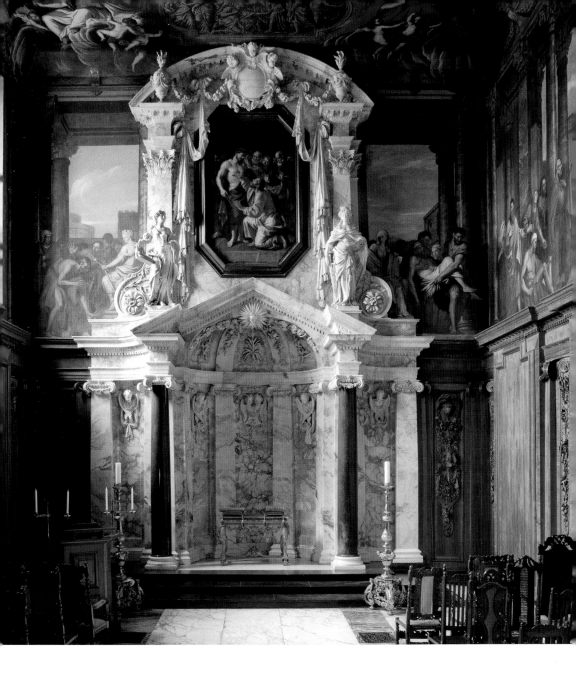

The Incredulity of St Thomas

ANTONIO VERRIO
Oil on canvas, 1692–93

SET INTO A FRAME of black marble, this painting forms part of the alabaster altarpiece carved by Samuel Watson. The Italian-born artist Antonio Verrio (1639–1707) was commissioned by the 1st Duke of Devonshire (1640–1707). The Chatsworth archives show that on 19 December 1693 payment was made for fixing the painting over the altar in the Chapel; Verrio himself was paid on 11 October 1693. Verrio was also responsible for the earlier ceiling paintings commissioned for Chatsworth by the 1st Duke, which can be seen above the Great Stairs and in the Great Chamber of the State Apartment.

It has been proposed that Louis Laguerre's *Christ Healing the Sick*, on the main wall of the Chapel, and *Christ Healing the Blind Man*, in a panel on the ceiling, both refer to the restoration of the nation's religious health under Protestantism following the Glorious Revolution of 1688, in which the 1st Duke was so instrumental. The same cannot be said of Verrio's *The Incredulity of St Thomas*, the subject of which is also repeated in a panel on the ceiling. Retired Keeper of Collections, Peter Day, has suggested that St Thomas, who is the patron saint of architects, may have been the 1st Duke's personal choice; as rebuilder of Chatsworth, the 1st Duke considered himself to be a great architectural patron. Peter has also suggested that the subject of Doubting Thomas was chosen as a subtle illustration of the Cavendish family motto: *Cavendo Tutus* ('safety through caution').

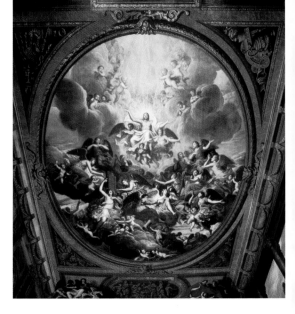

CHAPEL CEILING:
The Ascension of Christ

LOUIS LAGUERRE (1663–1721),
Oil on plaster *c.*1690s

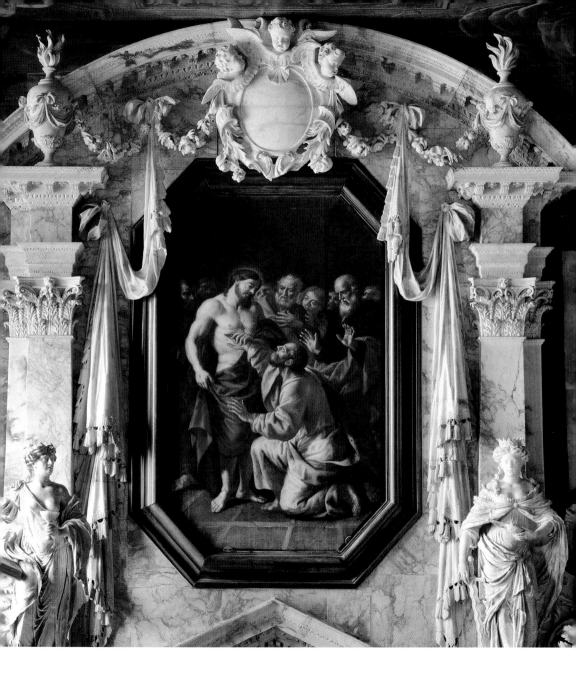

Carefree Man

ALLEN JONES
Bronze, 2001

AMANDA AND I went to see Allen Jones (b. 1937) in his studio in
Charterhouse Square in London to look at some paintings
which he thought might interest us. While there, we saw an
intriguing maquette for this life-size bronze figure on Allen's
worktable. At the time we were living in North Yorkshire, in a
house with a garden that was big enough to accommodate
some sculpture.

Allen had already made the Picnickers' Screen (now at
Chatsworth), so he knew the garden. We wanted something
eye-catching to go on the lawn on the eastern corner by the
terrace that surrounded the south and west sides of the house,
and *Carefree Man* proved to be a good choice for the site,
where it lived very happily through two or three Yorkshire win-
ters and summers.

When we came to live at Chatsworth in 2006, the scale of
the garden around the house was too grand for this cheerful
figure. We placed it on what had always been known as the
Mercury Landing, named in honour of the 19th-century bronze
that was cast after Giambologna's 16th-century original in Flo-
rence, acquired by the 6th Duke, and which now resides in the
Dome Room, pointing the way to the Great Dining Room.

I am pleased with *Carefree Man*'s placement. Visitors now
enter through the North Front Hall and then pass through the
Painted Hall. They then climb two flights of stairs to reach
the State Apartment. *Carefree Man* is on the landing after one
flight of these stairs and I hope is regarded as a friendly, wel-
coming sight, with his trilby hat tipped forward in greeting.

We have asked Allen Jones if he regards this sculpture as
in any way a self-portrait, but he has said not. Nevertheless, it
is as cheerful and yet as steely as he is.

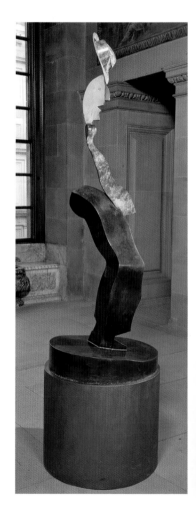

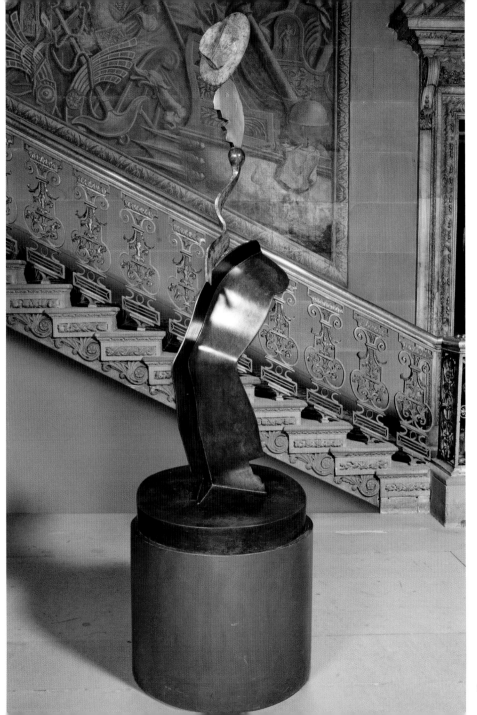

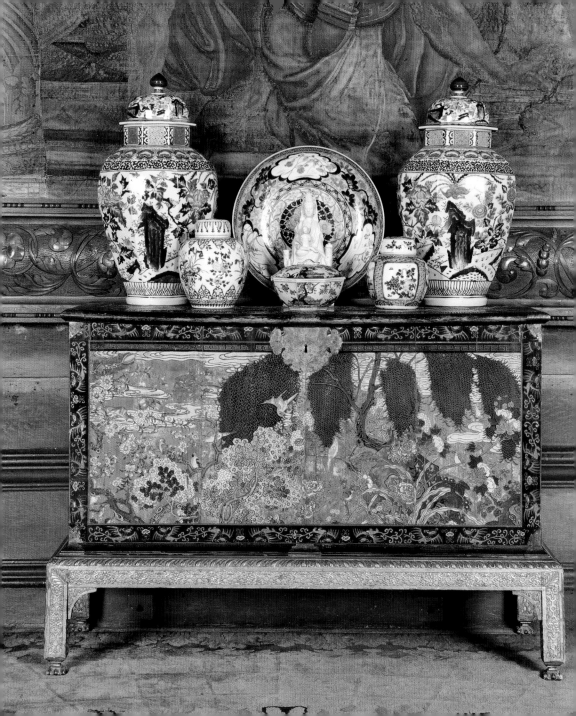

Queen Anne Coffers

Faced with panels of 17th-century Chinese Coromandel lacquer
and English Bantam work, c.1705

THESE TWO CHESTS are pieces of mongrel furniture that have always fasci-
nated me. The furniture itself is not very interesting, but the panels of
incised polychrome and gilt-decorated Coromandel lacquer are, partly
because they were rejected from their original purpose of covering the
walls of the State Closet, three doors down from where
these chests now stand. Highly decorated panels of this
sort, along with many other Far Eastern goods, such
as silk, were shipped from Japan to the Coromandel
coast, where the East India Company was based, and
made up into shipments for Europe.

The 1st Duke of Devonshire was determined that
the suite of State Rooms on the second floor of the
south front of his new house should be decorated by
the very best artists and artisans then available. This
'Coromandel' was then as fashionable as the blue and
white Delft china and the huge pier glasses that he also
commissioned for these rooms.

In 1691 these panels were installed in the State
Closet by the royal cabinetmaker Gerret Jensen, but
only nine years later, for reasons unknown, the panels
were taken down and used to decorate these chests. It
is strange that the panels were fitted onto the frame-
work of the chests in no particular order. A close look
will show that clouds reflected in water come to an
abrupt halt and give way to trees and plants. I cannot
believe they were arranged like this when they were
in the State Closet. Jensen's itemised account for fit-
ting out that closet was for 'japanning the Closet and mending the Japan',
so perhaps some panels had been damaged in transit from the Far East,
and after a few years it was decided that the damage was just too great.

William and Mary Perfume Burner

PROBABLY PHILIP ROLLOS
Silver, c.1690

FROM ANTIQUITY perfume burners were an essential household item, used to scent a room by burning aromatic oils or dried herbs. Burners made from clay, copper, pewter or brass were once common, but few survive. The Chatsworth perfume burner is remarkable not only as a rare survival of the type but also because it is made entirely from silver, and is by far the largest and heaviest example yet recorded.

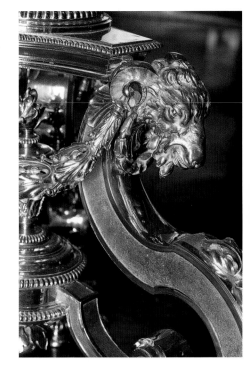

During the mid- to late 17th century there was a brief vogue for pieces of furniture made entirely from silver. This fashion first appeared at the court of Louis XIV and not surprisingly flourished; the original furnishings of the Galerie des Glaces at Versailles included a vast suite of silver tables and candle stands. Few pieces of silver furniture survive today, as the precious metal was easily melted down and recycled into newly fashionable objects or to release much-needed cash in hard times – as was the case in France, where it became necessary for Louis XIV's silver furniture to be melted down to fund military campaigns.

The Chatsworth perfume burner is therefore very special. How and when this object entered the Devonshire collection is unclear, although it is thought to be part of the group of large-scale silver acquired by the 1st Duke of Devonshire. Parts of the burner are marked 'PR', which may indicate that the maker was the French Huguenot immigrant Philip Rollos (c.1660–after 1715). It is also marked with an assay gouge of a type which suggests that the burner was produced on the continent, and possibly later imported and sold by Rollos in London.

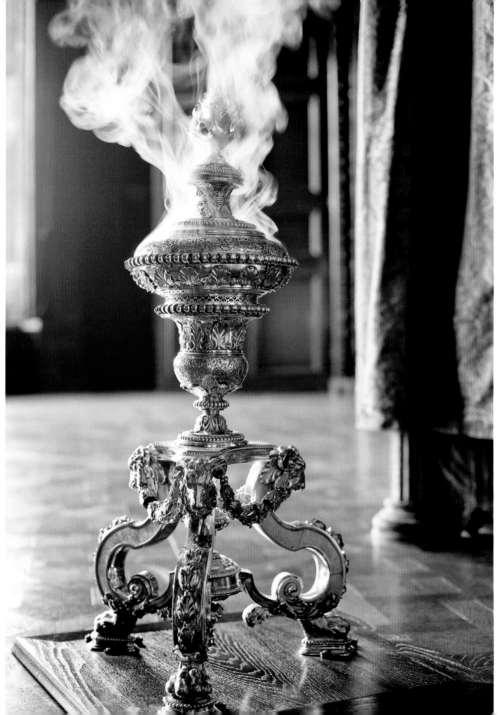

An Allegory of Peace

SIMON VOUET
Oil on canvas, c.1627–32

THE SEATED FEMALE FIGURE holds an olive branch, symbol of peace, in her right hand. She rests her left hand on a shield, indicating that the tools of war have been laid down, and she is crowned by a wreath of laurel, suggesting that peace is victorious over war. There are two putti to the lower left, and another flying putto holds an olive wreath and palm, signifying Christian Victory. In the background can be seen a classical building with steps, with figures entering and leaving. The shield bears the arms of Anne of Austria, Queen of France, consort of Louis XIII.

Simon Vouet (1590–1649) was a prominent artist of the early and mid-17th century, and was partly responsible for the introduction of the Italian painting style into France. Specialising in large-scale religious and mythological paintings, he had several prestigious aristocratic patrons, including Louis XIII. The inclusion of the arms of Anne of Austria would suggest that the painting was originally a royal commission, possibly for the Palais de Luxembourg. The allegorical subject has been thought to refer to the Peace of Westphalia, signed in 1648, which brought about religious tolerance between Christians, although more recent studies of Vouet's works would suggest that this is one of his earlier pieces.

This painting is believed to have been acquired by the 1st Duke of Devonshire. First recorded in sketches made by the sculptor Samuel Watson between 1689 and 1715 at Chatsworth, it was noted as hanging in 'the Duke's Bed Chamber'.

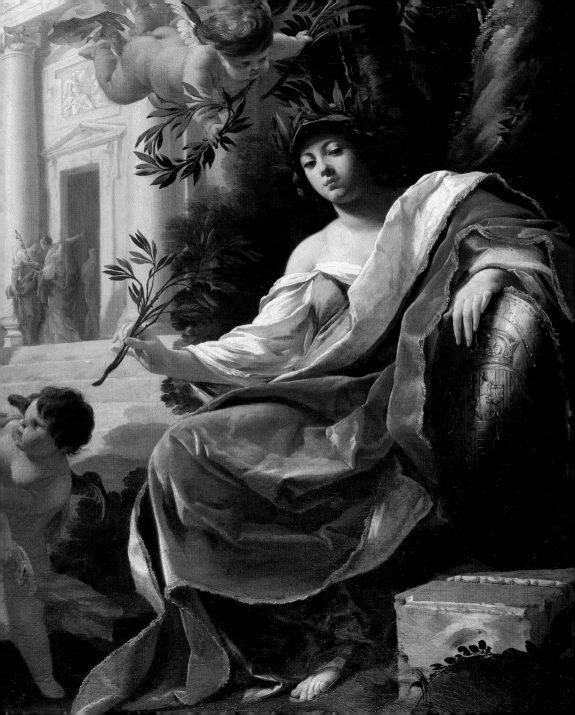

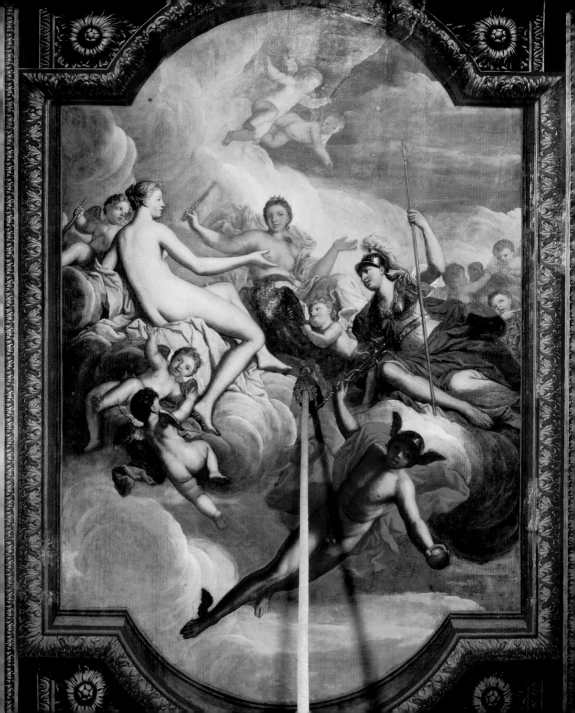

The Judgement of Paris

LOUIS LAGUERRE
Oil on plaster, c.1700

THE REBUILDING OF CHATSWORTH by the 1st Duke of Devonshire was a conscious exercise in demonstrating the power, wealth and importance of the five-generation-old Cavendish dynasty. Everything was to be of the highest quality, and that meant using artists patronised by the Duke's own patrons, King William III and Queen Mary.

The paintings in the State Closet are all carefully designed political statements. The allegorical language used by the artists, principally Louis Laguerre (1663–1721) and James Thornhill (1675–1734), would have been clearly understood by all the Duke's guests. We have no copies of the written briefs to the artists, and the significance of most of the subtler signals is now largely forgotten.

The State Closet, the last and most private of the so-called State Rooms, would have been for the private use of the person grand enough to use the State Bedchamber next door. Laguerre's painting on the ceiling shows the well-known theme from classical mythology of Juno, Venus and Minerva engaged in a contest. The winged Mercury holds a golden or orange fruit in his hand and has been sent to find Paris, who will judge which of these three powerful and competitive women is the most beautiful. In the Chatsworth interpretation Mercury is depicted swooping down from the ceiling with what I am sure is an orange in his hand, ready to present it to the

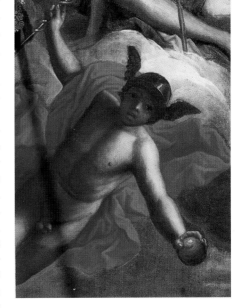

Prince of Orange's wife, Mary, thus marking her as the fairest of them all. It is a rather charming classical compliment from the Duke to his Queen. The fact that oranges were not cultivated in Europe until the late Middle Ages, and that the fruit's inclusion here is thus completely anachronistic, in no way lessens the charm of the compliment.

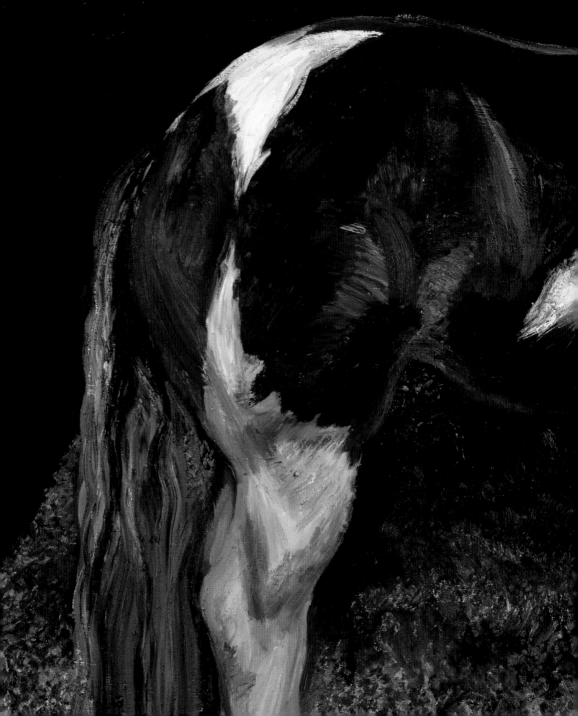

Skewbald Mare

LUCIAN FREUD
Oil on canvas, 2004

MY MOTHER FIRST SAW *Skewbald Mare* in the artist's studio in the spring of 2004 and was much taken by it. The painting was subsequently finished in time for a two-venue exhibition of recent paintings and prints by Lucian Freud (1922–2011) and was first shown at the Wallace Collection in London, together with Freud's *Four Eggs on a Plate*, which my mother had been given by the artist. My father, my wife and I went to see it. On our combined recommendation the Directors of the Chatsworth House Trust agreed to acquire the painting.

The work is particularly striking because of its unusual composition. Although Freud had painted horses before and was well known for his love of horses, and especially racehorses, his *Skewbald Mare* is a radical portrayal of its subject. The painting depicts a skewbald mare standing in a loose box at a riding school in East London. Unusually, the horse's head is excluded; Freud was not interested in the animal's head, which he considered weak, and so he concentrated on the body. Apparently the horse revelled in having her flanks stroked, and it is this aspect that Freud has brought out.

This portrait is far removed from the traditional European painting of an individual horse or racehorse, commissioned by a proud owner. Here it is the artist who has determined what is significant and how we should see it.

Portrait of Richard Boyle, 3rd Earl of Burlington

GEORGE KNAPTON
Oil on canvas, 1743

THE VISITORS' ROUTE includes the whole length of a gallery dedicated to the 3rd Earl of Burlington (1694–1753) and his collections, which helps to explain his influence on the Devonshire Collection and therefore Chatsworth. This rather severe portrait is rightly central to the picture-hang in the gallery.

Lord Burlington's achievements were formidable. He is perhaps most famous for reinventing English architecture in the new Palladian style, inspired by the Italian architect Andrea Palladio (1508–1580). Through the entrepreneurship of the 1st, Great, Earl of Cork in the 16th and early 17th century, the Boyle family, of which Burlington was the last in the male line, had established a major presence in Ireland, especially in counties Cork and Waterford. They were made Earls of Burlington in 1664.

The iconography of this portrait by George Knapton (1698–1778) is not subtle. The garter star and ribbon are prominently displayed, as is the red leather volume held in the sitter's right hand bearing the title *INIGO JONES*. One of England's greatest architects, Jones revived the architecture of Palladio long before Burlington. John Michael Rysbrack's bust of Jones can be seen in the background of the painting (the real marble bust is placed next to this portrait). Clearly Burlington, proud of his own career, is stating his connection with Jones and confidently asserting his place as the leading tastemaker of his generation. Viewing the paintings he bought and the furniture he commissioned, shown in this gallery, it is impossible not to agree that he was a man of wonderful taste.

The marriage of his daughter Charlotte to the 3rd Duke of Devonshire's son so horrified that Duke's wife, Catherine Hoskins, that she left Chatsworth to live in Eyam in protest: there must have been something scandalously awry with the Burlington family, or at least their reputation, to have caused such a rift in the Devonshire marriage.

Portrait Bust of Inigo Jones

JOHN MICHAEL RYSBRACK
(1694–1770)
Marble, *c.*1725

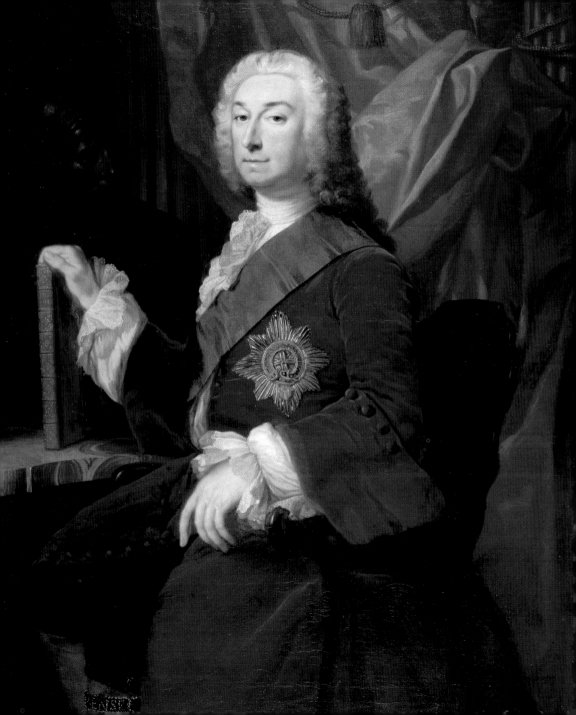

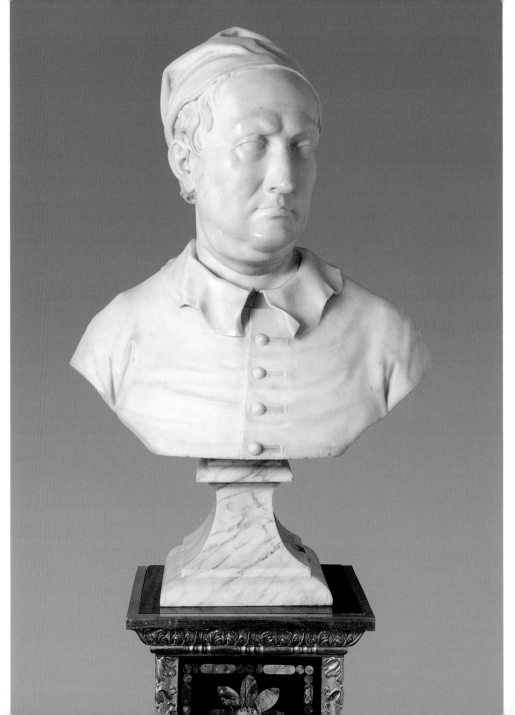

Busts of Andrea Palladio and Inigo Jones

JOHN MICHAEL RYSBRACK
Marble, c.1725

IT WAS EASY TO CHOOSE the busts of Andrea Palladio (1508–1580) and Inigo Jones (1573–1652) to flank the Knapton portrait of the 3rd Earl of Burlington. Commissioned by Burlington as a pair, they represent his two intellectual and architectural heroes.

Palladio was one of the most influential architects in the Western world. As well as designing sublime houses in the Veneto and thus keeping the flame of classical architecture alive, he has influenced many churches, bank buildings and other institutional edifices across Middle America. However, here he is portrayed in ordinary clothes and a workman's cap. His admirer Lord Burlington, to the right, is dressed to show his importance and success with the emblems of the Garter prominently displayed ... and yet Burlington regarded himself as the student and Palladio and Jones as his teachers.

The source of the image for the bust of Palladio is uncertain; it is probably a portrait, now lost, which was engraved for the frontispiece designed by William Kent to Lord Burlington's book of Palladio's designs. But the cap and the buttons on his shirt are strikingly similar to those in the Van Dyck drawing that was the inspiration for the bust of Inigo Jones on the other side of the portrait of Burlington.

The bust of Jones (see p. 40) may have been a maquette for the full-size figure of him by Rysbrack (1694–1770) now at the entrance to Burlington's Chiswick House; it was inspired directly by Anthony Van Dyck's drawing of him, which Burlington owned and is now at Chatsworth.

We should be grateful for Burlington's tremendous respect and enthusiasm for these two extraordinary designers; he did much to re-establish their importance and that of classical architecture too.

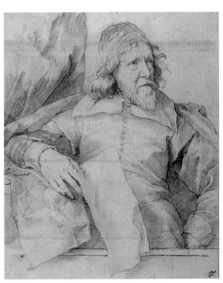

Inigo Jones
SIR ANTHONY VAN DYCK
(1599–1641)
Black chalk on paper

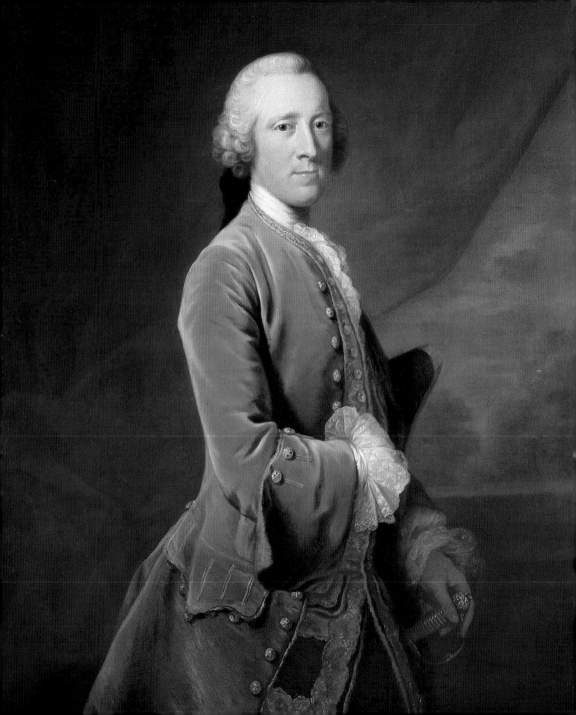

Portrait of the 4th Duke of Devonshire

THOMAS HUDSON
Oil on canvas, c.1750

THIS PAINTING BY Thomas Hudson (?1701–1779) is perhaps the most attractive of all the 18th-century portraits at Chatsworth, and a recent acquisition, purchased at auction by my grandfather. One of his *very* few additions to the collection, he must have been proud of it as he had the image copied in a mezzotint.

The 4th Duke (1720–1764) made major changes to the landscape and buildings at Chatsworth, commissioning James Paine to build a new bridge over the Derwent, further upstream from its predecessor. That new approach brought the drive across the park from the south and west, presenting visitors with the view that we all now know and love, a very different view from the first impression planned by Bess of Hardwick when she built the first Cavendish house at Chatsworth in the 1550s, and by the 1st Duke, who remodelled that building at the end of the 17th century. Paine also built the Stable block up behind the house to the northwest (then, the 18th-century equivalent of a garage block). Today it houses shops, cafés and restaurants, staff accommodation, offices and storerooms, all necessary for our modern commercial activities and very far removed from its original purpose.

When Marquess of Hartington, the 4th Duke married Charlotte Boyle (1731–1754) in 1748, and they had four children in quick succession before Charlotte died at the age of 23. Charlotte was the architect Lord Burlington's only surviving child, and thus his great wealth was inherited by her eldest son, William, the eventual 5th Duke of Devonshire. The 4th Duke never remarried and devoted his life to politics; he was Lord Lieutenant of Ireland and briefly Prime Minister of England. He died in 1764, aged only 44, worn out by the life of a senior politician.

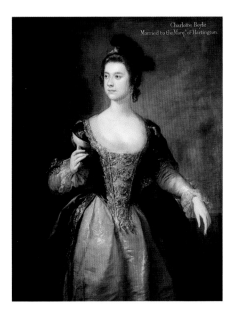

Portrait of Lady Charlotte Boyle, Baroness Clifford and Marchioness of Hartington

GEORGE KNAPTON
Oil on canvas, mid-18th century

Portrait of William Kent

BENEDETTO LUTI
Oil on canvas, 1718

THE LAST PAINTING in this gallery is a charming small portrait of William Kent (1684/5–1748) by Benedetto Luti (1666–1724). Although we have hung this portrait in the gallery dedicated to the architect Lord Burlington, Kent was also well known to the 3rd Duke of Devonshire (1698–1755). The Duke commissioned Kent to rebuild Devonshire House in Piccadilly after it had burnt down in October 1733. Kent also designed a great deal of the furniture for the new Devonshire House, much of which is now at Chatsworth.

Kent was also extremely important in the history of the garden at Chatsworth. It was he – rather than Lancelot 'Capability' Brown (1716–1783), who has historically been 'blamed' – who replaced the 1st Duke's formal French garden with the more Arcadian naturalistic spaces that we have today.

Kent was on very close terms with Lord and Lady Burlington. He taught her to draw and paint, and there is a charming sketch by Kent of Lady Burlington (*née* Dorothy Savile) at her easel, with the Kent desk and mirror he designed for her, both pieces of furniture distinguished by the Savile owl carved upon them.

Kent designed most of the furniture in this gallery, the ornate small table immediately below his portrait being one of his most exuberant designs. Based loosely on a Corinthian capital, it is not really to my taste but is undoubtedly an interesting example of the fashion of the time.

The painter of this portrait, Benedetto Luti, was the leader of Roman fashion in the early part of the 18th century, much as Lord Burlington was in England half a generation later.

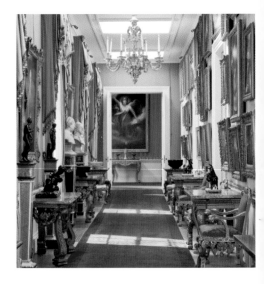

The West Sketch Gallery, as redisplayed in 2009

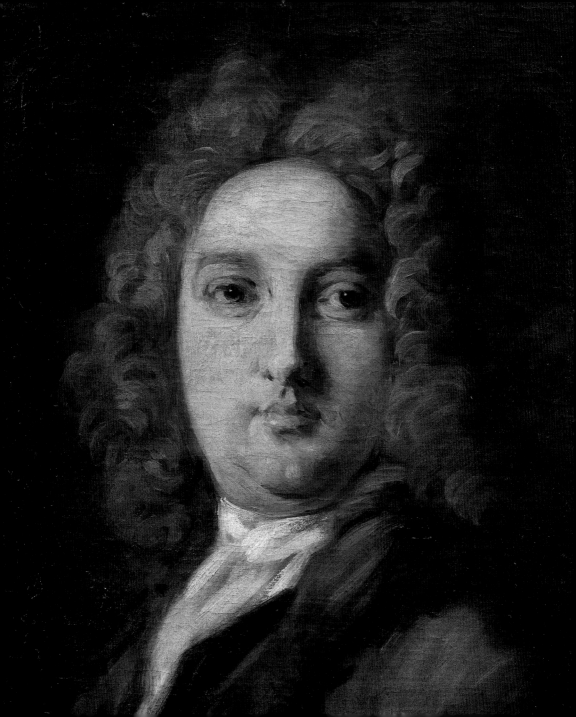

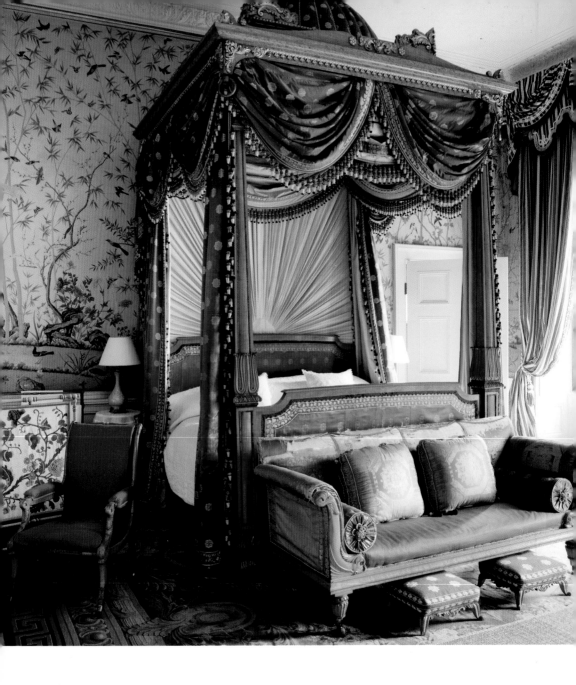

William IV Tester Bed

AFTER MOREL & SEDDON
Satinwood inlaid with tulipwood

AMANDA MOVED THIS BED to the Wellington bedroom from our own best guest bedroom because the fabric had deteriorated to such a degree that it could no longer be used without destroying it. My mother had already patched and mended the emerald green 'Empire' silk bed curtains once, and only the planned full-scale conservation will ensure their long-term survival.

When my parents moved back to live at Chatsworth in the late 1950s, my mother moved this bed from this suite of rooms, and it served her well for 50 years, but now it has been retired back to these east-facing former guest bedrooms, where it can be admired by our visitors. It has been moved around the house on a number of occasions, most notably when Queen Victoria came to stay in 1843. The 6th Duke returned to Chatsworth the day before the Queen arrived, having been kept away by the architect and gardener Joseph Paxton (1803–1865) for fear that he would interfere with the preparations. Interfere he did, as he decided that the new bed that had been supplied for the Queen in a room on the West front was not grand enough. With less than 24 hours to go before the Queen arrived, he ordered that this bed be taken down and moved to her room, and the new bed be taken down and moved here.

The pair of footstools were embroidered in the 1970s by Amanda, with some help from a friend, so this suite is a mixture of original and new, genuine and copy. The bed is 7 feet square, the mattress thus 49 square feet, and the sheets had to be specially made. I have slept in it – we tried out every guest bedroom when we came to live here in 2006 – and it is comfortable in a rather all-embracing, squashy way.

Suite of Painted wallpaper

Chinese, c.1830

THIS WALLPAPER WAS brought to Chatsworth in 1830 as sets of 25 or 40 rolls, each about 4 feet wide and 12 feet long. Birds and other small objects of interest were cut from the spare lengths and stuck on to the paper to provide more detail and disguise some of the joins.

In the Wellington bedroom – so named because the Iron Duke slept there during Queen Victoria's visit to Chatsworth in 1843 – there is a likeness of *Musa coccinea*. Until recently we had always called it *Musa cavendishii*; my great grandmother was probably responsible for this understandable howler, perhaps assuming that the wallpaper depicted the famous banana bought by Sir Joseph Paxton from a nursery in Epsom, Surrey, in 1835. He subsequently exported these bananas to the Pacific islands, where, after the staple commercial banana (*Musa Gros Michel*) was devastated by Panama disease in the 1950s, it became the most widely grown banana in the world. Unbeknown to Paxton, who named the banana '*cavendishii*', its proper Latin name is *Musa accuminata*. Despite this, it is still commercially known as the 'Cavendish banana'.

This story was debunked when my sister Emma Tennant was preparing for an exhibition of her watercolours held in the New Gallery at Chatsworth in the spring of 2013. She devoted much time and energy to researching the plants grown here by Paxton and the 6th Duke in the mid-19th century so that she could paint them for her show. In order to eliminate, as far as possible, any misinformation from her beautiful and fascinating catalogue she had it read by a number of botanical experts, one of whom, Dr Henry Noltie, botanist at the Royal Botanic Garden, Edinburgh, pointed out that the banana on the wall here was *Musa coccinea* – obviously, as it is bright red. In 2013 he kindly presented a *Musa coccinea* to Chatsworth, which we will plant at the west end of the display greenhouse, near to the real *Musa accuminata (cavendishii)*.

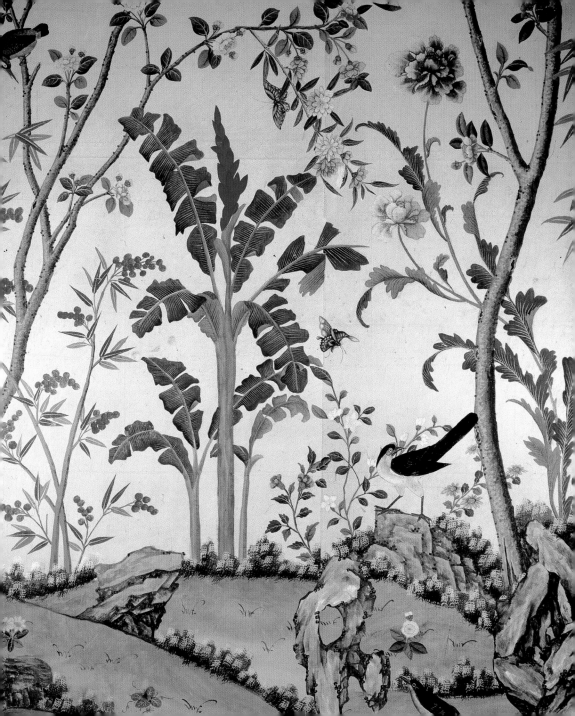

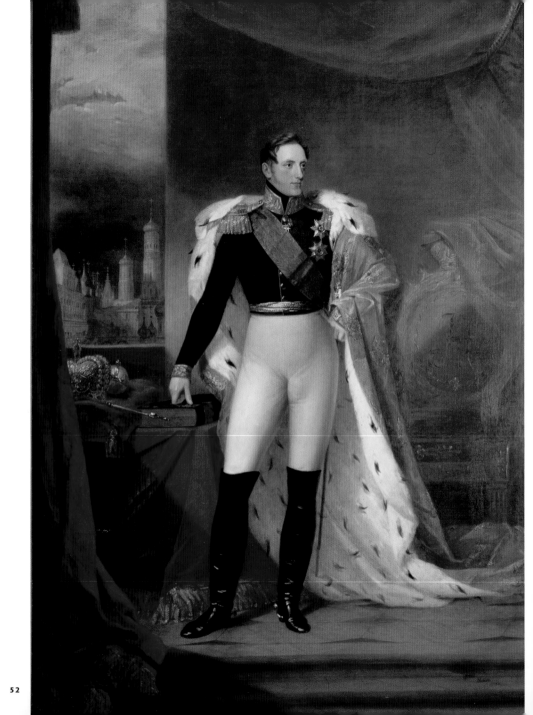

Portrait of Tsar Nicholas I of Russia

GEORGE DAWE
Oil on canvas, 1826

THIS PORTRAIT OF Tsar Nicholas I (1796–1855) and its pendant of Tsarina Alexandra Feodorovna (1798–1860) were displayed by my parents at the far end of the Carriage House Restaurant in the Stables. By the time we arrived at Chatsworth in 2006, all things Russian had become much more fashionable, and therefore valuable, including Russian subjects by British artists such as George Dawe (1781–1829). In 2009, when we restored the Oak Stairs to their original appearance, we had the perfect opportunity to return these paintings to the home intended for them by the 6th Duke.

This is the first coronation portrait of the Emperor to have been commissioned. George Dawe was engaged as court painter for Nicholas I's coronation in Moscow, and the Duke had been sent as the British Ambassador Extraordinary for this great occasion, which was held on 22 August 1826.

The painting was unveiled at the ball given by the Duke on 10 September to celebrate the coronation. He had managed to keep his commission a secret, so the assembled international grandees were as surprised as they were impressed by this gesture of friendship and admiration from the Ambassador Extraordinary for the new Tsar. The ball lasted till seven o'clock the next morning, and, according to the usually modest and reliable Duke (from his diary), the Empress told him afterwards that his was the best of all the balls given by the various ambassadors, a compliment of surprising importance to the Duke, who was competitive in such matters.

The portrait of the Tsarina was painted some time after the coronation and thus was not part of the display at the ball.

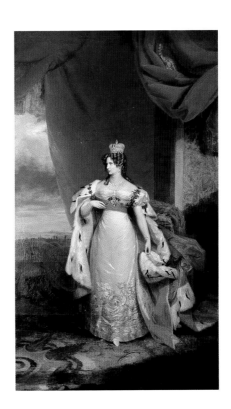

Portrait of Tsarina Alexandra Feodorovna of Russia,
GEORGE DAWE
Oil on canvas, after 1826

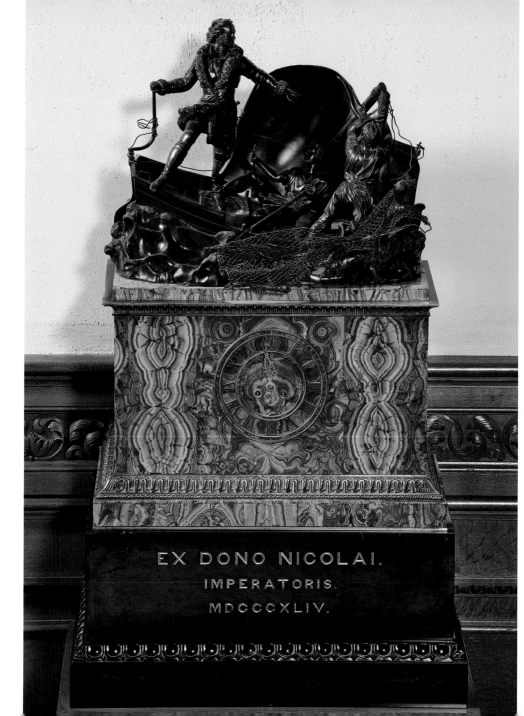

EX DONO NICOLAI.

IMPERATORIS.

MDCCCXLIV.

Table, Ornamental Clock and Monumental tazze

RUSSIAN

Malachite, bronze and gilt bronze, mid-19th century

THE WORD 'MALACHITE' is derived from the Greek *molochitis litos*, which means 'mallow-green', and the mineral (a bright-green copper carbonate hydroxide) was used as a pigment for paints from antiquity until the early 19th century. By the time of the coronation of Tsar Nicholas I (1826), huge deposits of malachite had been discovered at Nizni-Tagil, in the Ural Mountains. This ready supply, coupled with the extraordinary skill of the stonemasons, combined to make malachite-veneered furniture extremely fashionable in the 19th century.

This group of objects were all coronation gifts from the newly crowned Tsar to his old friend the 6th Duke of Devonshire. Russian stonemasons had established a technique for applying malachite to furniture as a thin veneer, the stone sawn into millimetre-thin slices and then arranged with the grain making symmetrical patterns. The effect is similar to the so-called 'oyster' veneers using decorative woods to decorate furniture in the 17th century, but the result is unmistakably 19th-century Russian.

The Duke had first met the then Grand Duke Nicholas in London in 1816, and he came to stay at Chatsworth in November of that same year: as a mark of their friendship they weighed each other and recorded their weights, which were exactly the same, at 13 stone 7 pounds. The weighing machine and weighing book are both still at Chatsworth, although this is not a custom that I have any plans to revive! The two remained friends all their lives, but they never spent time alone together after this first prolonged stay in Derbyshire.

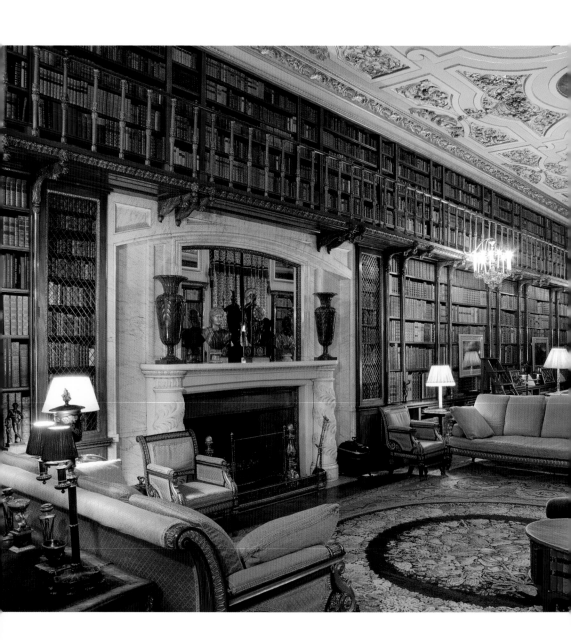

The Library

As so often at Chatsworth, this room is a complete mixture of styles. The ceiling is made of gilded stucco by Edward Goudge, and the paintings are by Antonio Verrio, one of the court painters favoured by the 1st Duke. The ceiling was completed by 1700 when this room was used as a Long Gallery. The rest of the room is pure Victorian, so these decorative schemes are more than 150 years apart.

Books, like contemporary sculpture, were a major collecting interest of the 6th Duke, and he would buy whole libraries at a time. He was also lucky enough to inherit the vast library of his kinsman, the scientist Henry Cavendish (1731–1810). Therefore, the Duke needed this space, and more, to house his ever-expanding collection. The 1st Duke's pictures were removed to be replaced by bookshelves; the only space that could be found for these 20 or so paintings was on the ceiling of the Ballroom (now the Theatre) where they remain, virtually unseen.

The carpet, certainly the largest in the house, was made for the 6th Duke in the Axminster factory. The design carefully mirrors the roundels in the ceiling above. Having been walked on for 180 years, it was in need of conservation. In 2012, under the expert supervision of our textiles curator, Susie Stokoe, a programme of careful washing and stitch treatment was begun.

The elaborate suite of simulated 'rosewood' and gilded seat furniture, comprising two massive sofas, four armchairs and eight side chairs, came from the Saloon at Devonshire House. Like the carpet, it was looking tired and is now being restored; the original turquoise and gold silk brocade is being copied.

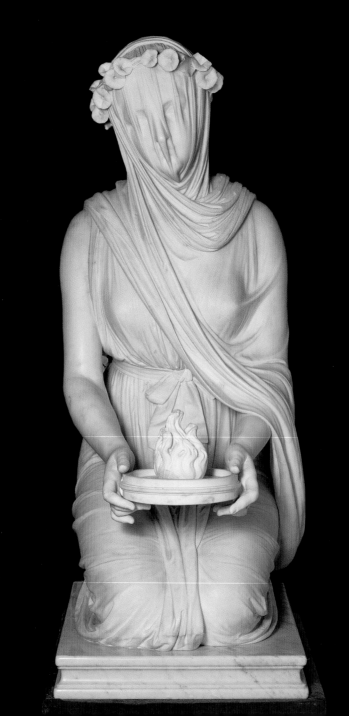

A Veiled Vestal Virgin (or The Veiled Tuccia Kneeling before the Altar of Vesta)

Raffaelle Monti
Marble, 1846–47

Although a recent arrival at Chatsworth, this is probably the best-loved and best-remembered object after the *trompe-l'oeil* violin door in the State Music Room. The sculpture was commissioned by the 6th Duke at the end of 1846 from Raffaelle Monti (1818–1881), who was working in Milan. It went straight to Chiswick House in west London and then to Compton Place, our house in Eastbourne in Sussex, until my parents brought it to Chatsworth in 1999 and installed it in the Sculpture Gallery. It remained there until the Sculpture Gallery was reorganised and put back to its original 1858 layout. Since then we have tried various places for the *Vestal Virgin*, including the Oak Room and the Dome Room.

Soon after the 6th Duke 'discovered' Monti, the artist moved to London, where he stayed for over 30 years. *The Veiled Tuccia Kneeling before the Altar of Vesta* is Monti's first recorded veiled figure, and this became a motif that he repeated very often for the rest of his career. This statue and another veiled figure by Monti, *A Circassian Slave in the Market-Place at Constantinople*, now at the Wallace Collection, were exhibited at the Great Exhibition, and this added enormously to the reputation of the artist.

A few years ago I had the great pleasure of walking the length of the Thames and was surprised, at reaching the lock in Lechlade, to find a full-length *Father Thames* (not veiled) also by Monti. I discovered later that this statue had originally been destined for some fountains at the Crystal Palace at Sydenham, a further indirect connection to Chatsworth via Sir Joseph Paxton who was first head gardener at Chatsworth from 1823 and subsequently the designer of the Crystal Palace, which was moved to Sydenham after its year of glory housing the Great Exhibition in Hyde Park in 1851.

The *Vestal Virgin* was much reproduced. It was cast in Parian porcelain by Copeland from 1861, and I am glad to say that we now sell a small version in our shop, beautifully made by Sculptured Arts Studio.

However well one understands the sculptor's brilliant technique, it is impossible not to be struck by this lovely thing, and I am not surprised that there is invariably a crowd of admirers around it.

Monumental Wall Lights

AFTER OSLER GLASS, BIRMINGHAM
Cut glass and gilt bronze, c.1840

MY MOTHER INSTALLED THESE wall lights in the Great Dining Room when she restored the room in 1963. They had been stored carefully since being brought from Devonshire House in Piccadilly after it was sold in 1923 by Duke Victor (1868–1938) and his wife, Evelyn (1870–1960).

Duchess Evelyn was a remarkable woman, who fully realised the importance of conservation and also understood that fashions change from generation to generation. As she had an aversion to Victorian art, and particularly to the 6th Duke's sculpture collection, she moved most of it out of the rooms that she used, but she did not dispose of it. She wrote long and charming letters about Chatsworth to her daughter-in-law Duchess Mary, my grandmother, making it clear that she realised

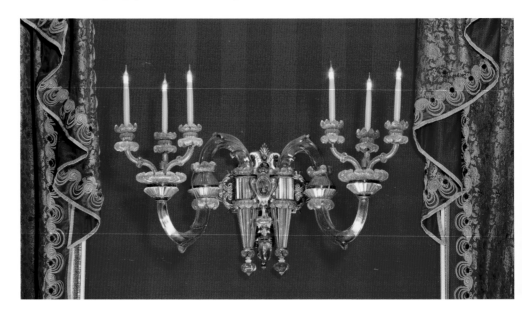

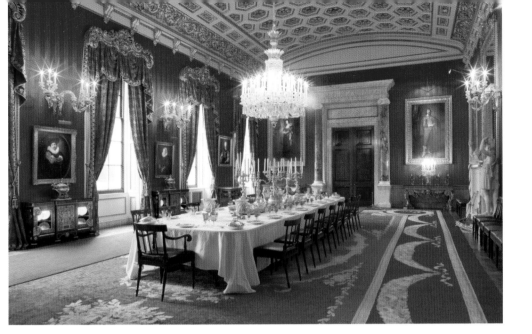

The Great Dining Room,
as redecorated by the
11th Duke and Duchess
Deborah

that the Victorian taste she so disliked would certainly come back into fashion again.

On the disposal of the vast Devonshire House she ensured that all the best doors, door cases, light fittings and other artefacts that could be saved were stored against some future useful purpose, and she has been proved right again and again.

In her book *The House* (2001) my mother wrote that she thought these ex-Devonshire House lights went well with the chandelier, and of course she was right. The wall lights and the chandelier are monumental objects in the best-quality cut glass of the 19th century. They are all in the style of Osler Glass, Birmingham (1807–1975), the company famous for producing the giant glass fountain at the centre of the Crystal Palace for the Great Exhibition of 1851.

The chandelier was made in the 1830s and supplied for the Gold Drawing Room at Chatsworth, and the wall lights some ten years later for the Crystal Staircase at Devonshire House, where they must have looked magnificent, lighting the massive cut-glass handrail and newel post of that most extravagant space. Sadly, the staircase did not survive the demolition of Devonshire House.

Group Portrait of Christian Bruce, Countess of Devonshire, with her Sons, William, 3rd Earl of Devonshire, and Charles, and her Daughter, Anne, Later Lady Anne Rich

DANIEL MYTENS

Oil on canvas, *c.*1629

ALL THE PAINTINGS in the Great Dining Room were moved to Chatsworth from Devonshire House by the 6th Duke when this room was finished in 1832. As far as I know, except for the East Wall, the pictures have been *in situ* ever since.

The family portrait of Christian Bruce (1595–1675) is in an appropriately important position. Without her good steward-ship it is unlikely that the Cavendish dynasty would have survived more than three generations beyond Bess of Hard-wick. Her husband, the 2nd Earl of Devonshire (1590–1628), had died young, only three years after he had succeeded to the earldom. Christian, married at 12 years of age and widowed at 32, was now solely responsible for her children – William, the 3rd Earl (1617–1684), who inherited the title when he was only 11, Charles (1620–1643) and Anne (1611–1638). With great difficulty, and at a tricky political time for the Royalist Cavendishes, Christian kept the estates intact and was able to hand them on to her son when he achieved his majority.

The painting is by Daniel Mytens (*c.*1590–before 1648), whose career was overshadowed by his contemporary the court portrait painter Anthony Van Dyck. Mytens was born in Delft in the Netherlands and came to London when in his early 20s, and it was not until Van Dyck's departure from England in 1621 that Mytens' career took off. He withstood challenges from Ger-rit van Honthorst and Peter Paul Rubens, but when Van Dyck returned to London in 1632, Mytens retired to the Netherlands.

The Cavendish family have been fortunate in their choice of wives: in many cases they have made more of a difference than their husbands to the well-being of the estates in Der-byshire, and Christian Bruce is a leading example of this.

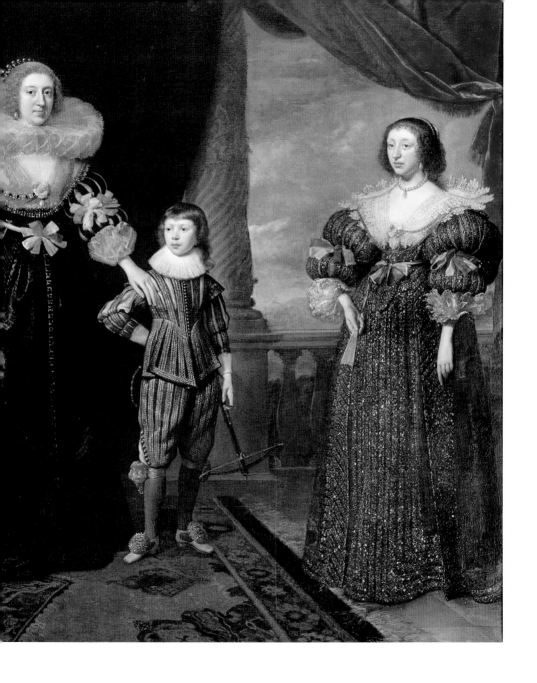

Pair of George I Pilgrim Bottles

ANTHONY NELME
Silver, London 1715–16

THESE VAST SILVER TROPHIES, which measure 86cm high, were probably commissioned to celebrate the coming of age of the 3rd Earl of Burlington in 1715. They are made by Anthony Nelme (active 1681–1722), a silver-smith who hailed from Herefordshire, became a freeman of the Goldsmiths' Company in 1679 and died in 1723. He was responsible for making swagger commissions, such as these objects and the Parker wine fountain in the Victoria and Albert Museum in London.

These are called pilgrim bottles because their shape is directly based on the leather water or wine bottles that pilgrims carried strapped to the saddles of their horses. Clearly, given the crafts-man's desire to please the client for such an important occasion as the com-ing-of-age of the immensely wealthy Earl of Burlington, the scale became irrelevant; size was everything.

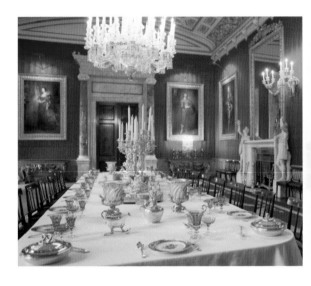

It is fortunate that we have such a large room and such an enormous table at its centre to support this immense display of what now might seem to be great vulgarity; but certainly the pieces are very interesting because the pilgrim bottles, and the much later candelabra by Paul Storr, made about 1813, are examples of works by the best craftsmen from different generations at the top of their game. When the table is laid for dinner for 40 people, which happens once or twice every year, all this silver (and more), all the flowers throughout the room and the very many candles create a won-derfully theatrical effect as the diners arrive through the door,

The Great Dining Room table, laid with items from the 6th Duke's plate

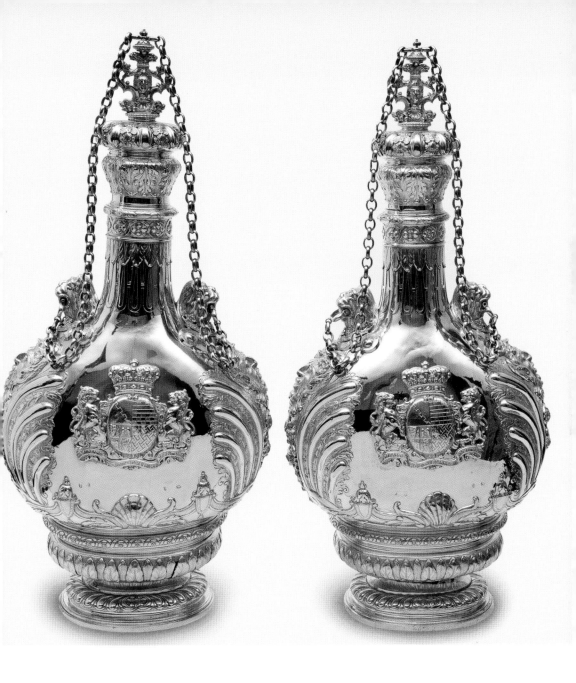

Head of Alexander the Great

ROMAN

Marble, c.AD 120

WE HAVE RETURNED the Sculpture Gallery as near as possible to how it looked in 1857, the year before the 6th Duke died. Sir Jeffry Wyatville had created a top-lit gallery for that Duke to display the objects he felt most passionate about – his collection of sculpture by his contemporaries – all collected by him or given or bequeathed to him by his friends in Rome, where he spent time with his step-mother, Duchess Elizabeth, the second wife and widow of the 5th Duke.

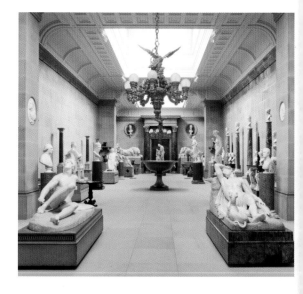

The Sculpture Gallery, as redisplayed in 2009

Today this collection is hugely admired by amateurs and experts alike, but 70 years ago taste was very different, and the probate valuation soon after my grandfather's death at the end of 1950, valued the contents of this room, including six pieces by Canova, at a mere £1,000. My great-grandmother, Duchess Evelyn, did not like this Victorian sculpture. My mother, who hugely admired the Bachelor Duke and all his works, did not like his choice of Derbyshire gritstone for the walls, and tried various decorative schemes to bring warmth to the room, including hanging massive sheets of red and green velvet on some walls and tapestries on others.

This antique bust is the exception in this display. It is the only antique work in the gallery and the only work not acquired by the 6th Duke; it was part of the collection of Richard Boyle, 3rd Earl of Burlington, and the 6th Duke placed it here. I find this bust very beautiful and perhaps a little plainer and more to my taste than the exuberantly perfect examples of high Victorian art.

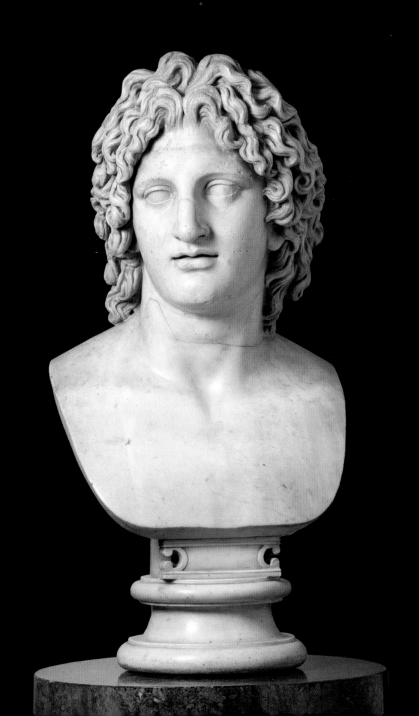

Tools of Antonio Canova

THE 6TH DUKE was a tremendous admirer of Antonio Canova (1757–1822). He first met him in 1820, having been introduced by Elizabeth, Duchess of Devonshire, his stepmother, who had gone to live in Rome after her husband's death. The Bachelor Duke was only one of a group of enthusiastic collectors who befriended the sculptor and other artists working in the same medium in Rome at that time.

Nothing gave the 6th Duke greater excitement or pleasure than accumulating marble columns, floors, fragments and statues by contemporary artists. It is not surprising that his enthusiasm was rewarded by a number of gifts from other expatriates visiting or living in Rome at the same time. He was an immensely generous man by nature: the giving of an object afforded him as much pleasure as owning it himself. He also liked curiosities, so one can imagine how pleased he must have been when Lady Abercorn (d.1827) gave him these five tools, which she had found in the artist's studio soon after his death.

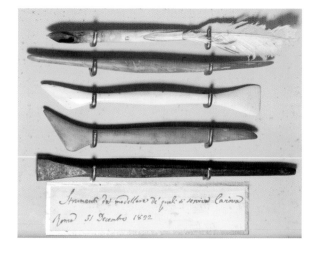

In the first of the Sotheby's 'Beyond Limits' sculpture exhibitions at Chatsworth in 2006 there was a wonderful statue designed by Damien Hirst called *St Bartholomew, Exquisite Pain*. It portrays the saint holding his flayed skin over his arm and standing on the sort of low, three-legged stool used by models in art classes. On that stool Hirst had had carved the tools of the sculptor, and they are identical to this set, left in a studio in Rome nearly 200 years earlier.

The Sleeping Endymion
ANTONIO CANOVA
Marble, 1819–22

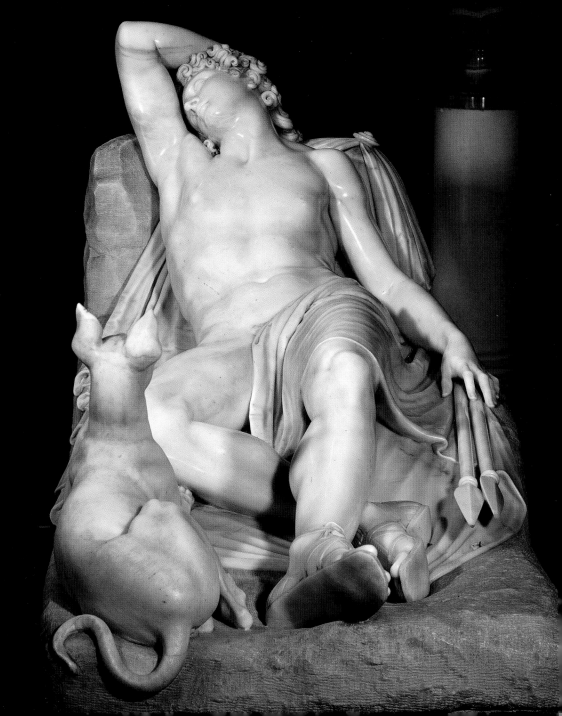

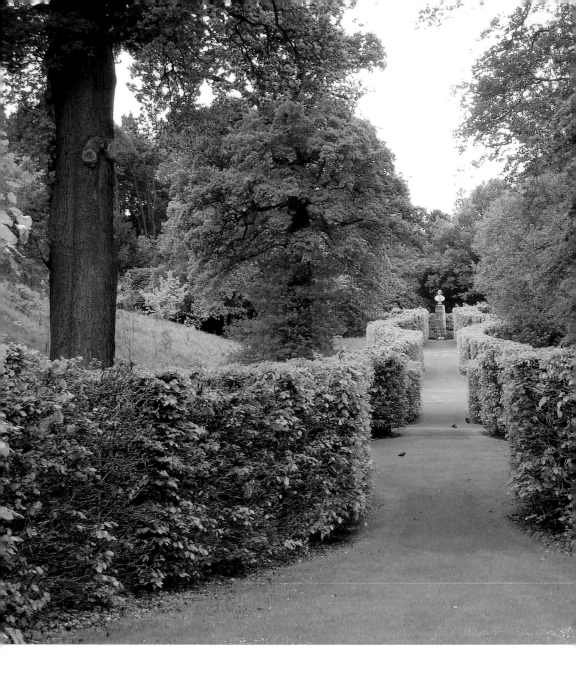

Serpentine Hedge

The Serpentine Hedge was planted when I was seven years old. I remember the double row of twigs, which seemed to grow hardly at all, but not the space before my mother planted the hedge. She'd seen a 'crinkle crankle' wall in a garden not far from Chatsworth and adapted that idea to join the hitherto rather lost bust of the 6th Duke (placed on top of a column he had acquired from the Temple of Poseidon at Cape Sounion) with the Ring Pond and thence the centre of the 1st Duke's greenhouse – the alignment was already there but virtually impossible to read.

A year after the hedge was planted, my mother continued her inspired work by planting the western semicircle of beech hedge around the Ring Pond. The stump of an enormous sycamore is still visible by the northern entrance to this enclosed space. Once this tree had been felled, the planting of the second semicircle, the completion of the circle around the Ring Pond, was possible.

Over the years the Serpentine Hedge and the circular surround to the pond have grown and grown. In 2008 I saw a photograph of the Serpentine Hedge in a 1958 edition of *Country Life* and realised immediately how much more attractive the hedges would be at a more modest height, and had the garden team reduce them by 6 feet

The northern end of the Serpentine Hedge is one of Sotheby's favourite sites for placing sculpture in their annual 'Beyond Limits' exhibition, and in fact the whole of the Ring Pond and Serpentine Hedge area is a wonderful backdrop for contemporary sculpture.

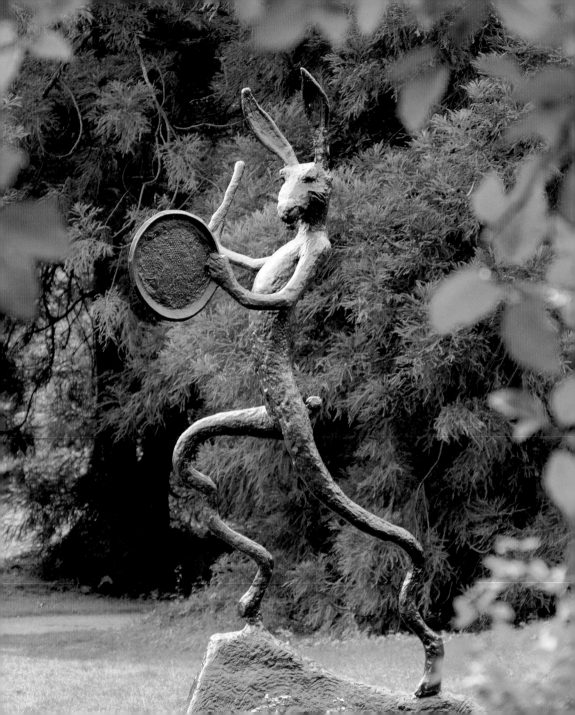

Drummer

BARRY FLANAGAN
Bronze, conceived 1996, cast 2004

AMANDA HAS LONG BEEN a fan of Barry Flanagan (1941–2009); she bought some of his drawings 30 years ago. In 1991 we were able to buy three of his sculptures: *Elephant, Leaping Hare on Curly Bell* and *Hare with Bird*.

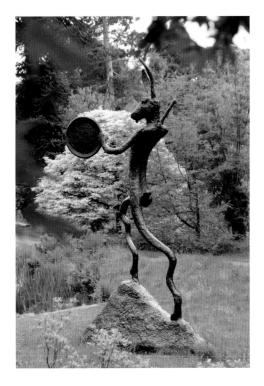

In 2004 I sold a two-year-old thoroughbred colt for what, for me, was a great deal of money. As this was a windfall, I had no hesitation in re-investing part of it in this sculpture. Amanda loved the piece, and we knew we wanted it at Chatsworth but had no idea where. A large work by an artist we hugely admire, we wanted to find just the right place for it, where we could see it often, ideally from different angles and distances.

Julian Hawkins, our driver, is also brilliant at making light and easily moved mock-ups of outdoor sculpture, and we moved his black-plastic and wire simulacrum of this work around the garden, trying it in many different places. It was not until Charles Ryskamp, the late and much-lamented ex-director of the Frick and the Morgan Library in New York, was staying with us in 2007 that we found the ideal placement. It was a lovely summer, and most evenings we spent an hour or so driving around the garden in a golf buggy with Charles considering various positions for this and other sculptures.

He plumped on this spot to the north of the Grotto Pond. From near or far it is an immediately cheerful sight. I smile every time I see it, and it reminds me how lucky we are to live at Chatsworth and how even luckier we are to have been able to acquire a few new things to go with the myriad old things.

Forms that Grow in the Night

Davⁱᴅ Nᴀsʜ
Oak, 2009

Dᴀᴠⁱᴅ Nᴀsʜ (b. 1945) made *Two Column Jump* as one of the artists' fences for the Chatsworth Horse Trials cross-country course in 2003. Two years later he made a site-specific work for us in the garden at Lismore Castle, in County Waterford in Ireland. In 2006 we asked David to make a site-specific piece for the garden here.

The site was chosen after a few visits from David and a lot of walking about. In the end he, Amanda and I all agreed on a site at the south end of the Pinetum close to the boundary ha-ha. The piece took quite a long time to make; David was very busy, and we were in no particular hurry. The three shapes that comprise *Forms that Grow in the Night* are from two fallen oak trees from Sussex, which were carved and then charred at David's studio in Blaenau Ffestiniog, north Wales; they were brought to Chatsworth and installed at the end of April 2009. Once installed, David charred them again and sprayed linseed oil over the charred wood. The charring not only changes the appearance of the sculpture but also ensures a much longer life than if the wood were left raw. Each piece of oak stands on a metal plate slightly raised from the ground to reduce the risk of the timber rotting from the base.

I find these three black lumps extraordinarily peaceful and calming. They are in tune with the surrounding quiet, wooded, enclosed landscape. The approach from the east or west along the main Pinetum path has become laden with pleasurable anticipation.

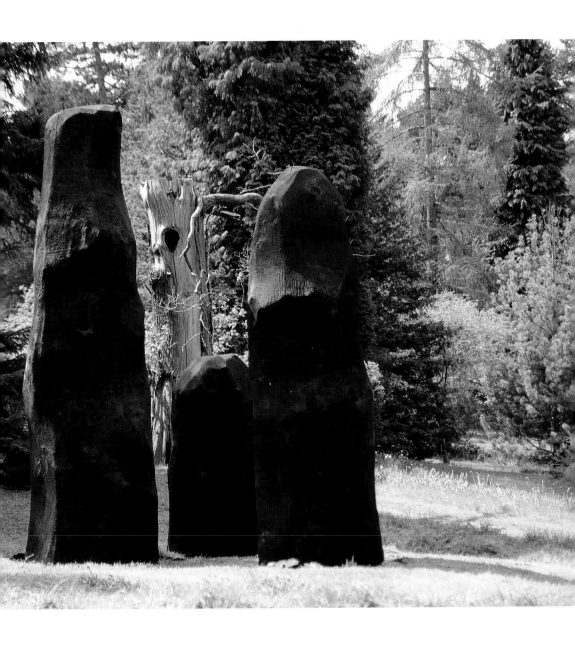

View from Head Gardeners' Benches

In 1829 the 6th Duke enclosed 8 acres of the park at the south end of the garden to make a Pinetum, a rather empty area where he and his gardener, Joseph Paxton, could plant many of the newly discovered conifers. They left the old oaks, some of them three or four hundred years old, and planted their new trees among and around these old leviathans. Many of the oaks are still there.

The 1830s and 1840s were a thrilling time for those interested in horticulture. Plant hunters searched the world for new plants that would grow in England's accommodating climate. Trees and shrubs from North and South America, China and South Africa arrived by the boatload. The 6th Duke sent several of his gardeners on plant-hunting expeditions.

In gardening the Duke was able to satisfy his passion for collecting *and* his insatiable desire for novelty. Paxton enabled his success; he was a brilliant gardener, who encouraged a whole series of junior lieutenants to learn how to make things grow. He experimented, and failures were far outnumbered by the extraordinary successes that he had both inside his massive greenhouses and out in the open.

The Pinetum is now mature. It includes trees planted by my parents and even a few by us, and these are creating a strong second generation of pines and firs. At the southwest perimeter of the Pinetum two plain garden benches face west: memorial benches named after two recent head gardeners. From these benches there is as good a view of Lancelot 'Capability' Brown's mid-18th century park as you could wish for.

As I write, we are embarking on a 20-year management plan for the whole of the park, a thrilling project that will improve even more the view from these seats. The park has become rather over-planted, and so with the expert help of Historic Landscape Management (HLM), and in close co-operation with the Peak District National Park and Natural England, we will attempt to recover a vista somewhat closer to what might be more recognisable to Brown and his predecessor William Kent.

The sweep of New Piece Wood, which circles the near horizon from the southern end of the park to the top of Edensor Lane, due west of the village, is the crowning glory of this view and the inspired idea of Brown.

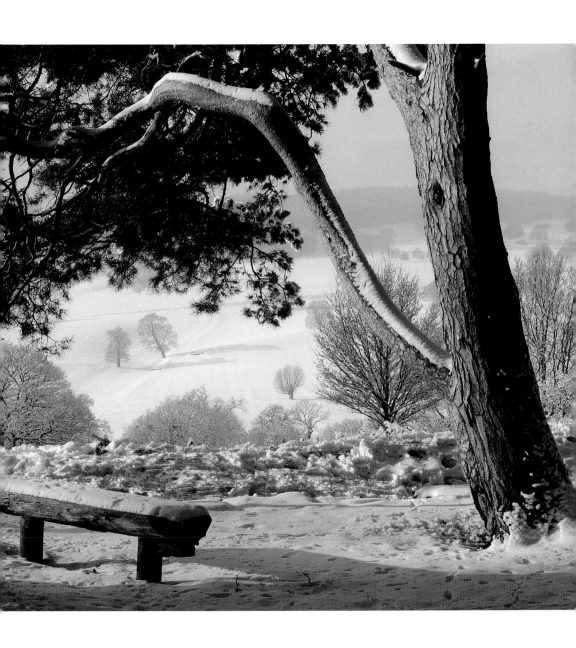

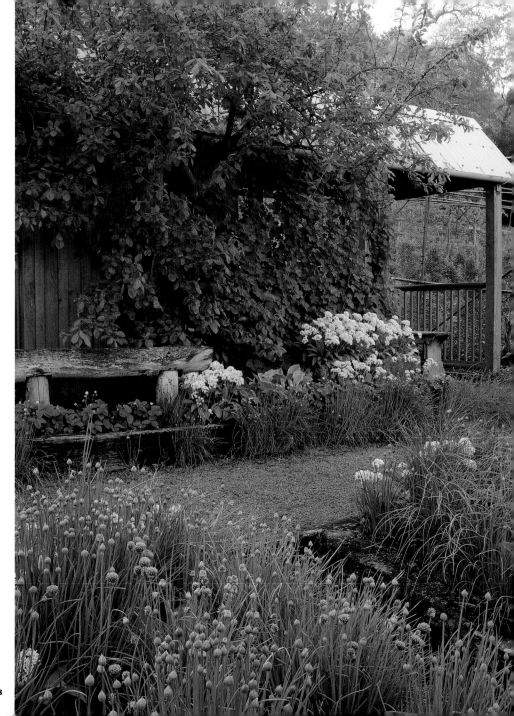

Blue Hut in the Kitchen Garden

THE KITCHEN GARDEN, built on ground formerly given over to paddocks for the carriage horses, was another one of my parents' brilliant additions to the garden at Chatsworth. Sir Joseph Paxton had the Chatsworth Kitchen Garden down at Barbrook, one of his few errors, as the land at Barbrook is flat and close to the river and consequently the spring frosts linger longer there than on any sloping ground. I think my mother's desire for early new potatoes and fresh peas and beans before the summer was over was one of the main reasons behind the new Kitchen Garden.

The greenhouses had been there since the late 19th century: they were as derelict as the surrounding paddock, and my parents nearly had them removed. Instead they established an ornamental and productive kitchen garden to supply the house and to interest the visitors. At its centre they put the Blue Hut beside the rill, facing out towards the west park. I don't think the hut ever had a specific use; it was more a piece of visual punctuation, possibly subconsciously inspired by my mother's love of Beatrix Potter's Peter Rabbit books.

The hut is perfectly sited, with the wonderful distant view of the park, a middle view of the roofs of the stables and the immediate prospect of an immaculately maintained vegetable and flower garden. The open loggia is sheltered from any wind, and the table is large enough to accommodate all the Sunday papers and a flower basket. Sitting at this table on a sunny summer afternoon is one of the great pleasures of living at Chatsworth. If the wind is in the west, which it usually is, music from the brass band playing on Sundays (an idea of my father's which we have continued) drifts up to add to the pleasure of an idle hour or two.

First published in 2013 by
Scala Arts & Heritage Publishers Ltd
21 Queen Anne's Gate
London SW1H 9BU, UK
www.scalapublishers.com

In association with
Chatsworth
Bakewell
Derbyshire DE45 1PP

The publishers are grateful for permission to
reproduce the following:
Carefree Man (see pp. 28–9) © Allen Jones
Drummer (see pp. 72–3) © Barry Flanagan, courtesy
Rowford Process and Waddington Galleries
Forms that Grow in the Night (see pp. 74–5) © David Nash
Skewbald Mare (see pp. 38–39) © The Lucian Freud Archive
Sounding Line (see p.19) © Edmund de Waal,
photograph by Helen Binet

ISBN 978-1-85759-839-1

Photography by Matthew Bullen, Diane Naylor, John Riddy, Glen Segal
with Melvin Booth, Scene Photography and David Vintiner
Edited by Julie Pickard and Esme West
Designed by Nigel Soper
Printed in Singapore

10 9 8 7 6 5 4 3 2 1

ACKNOWLEDGEMENTS

WE COULD NOT HAVE even considered writing
these notes without the intellectual support of
those so much more knowledgeable than us:
Matthew Hirst, Head of Arts and Historic
Collections at Chatsworth since 2007, and his
departmental colleagues, in particular Eleanor
Brooke; Jonathan Bourne, an old friend who has
explained so much with such patience; and Peter
Inskip, the architect responsible for the re-
ordering and refurbishment of the old square
and the 19th-century wing. As well as these three
titans of knowledge there is the whole team at
Chatsworth and beyond who make the place
work, as work it does. We are very proud to
work alongside so many dedicated, clever and
enterprising people who, some over many years,
have underpinned the renaissance of Chatsworth
so brilliantly achieved by my parents.

FRONT COVER:
Portrait of Georgiana, Duchess of Devonshire
THOMAS GAINSBOROUGH
Oil on canvas, 1785–87

FRONT COVER FLAP:
View of the south and west fronts, looking across
the River Derwent

BACK COVER:
A Man in Oriental Costume (or *King Uzziah
Stricken by Leprosy*)
REMBRANDT VAN RIJN
Oil on wood panel, *c.*1639

FRONTISPIECE:
View of the south front from across the canal pond